VOICES OF AMERICA

A *Chicago Firehouse*

STORIES OF WRIGLEYVILLE'S ENGINE 78

VOICES OF AMERICA

A *Chicago Firehouse*

STORIES OF WRIGLEYVILLE'S ENGINE 78

Karen Kruse

First Printed 2001.
Reprinted 2001, 2002.

Published by Arcadia Publishing,
an imprint of Tempus Publishing, Inc.
3047 N. Lincoln Ave, Suite 410
Chicago, IL 60657

Printed in Great Britain.

Library of Congress Catalog Card Number: 2001087167

For all general information contact Arcadia Publishing at:
Telephone 843-853-2070
Fax 843-853-0044
E-Mail sales@arcadiapublishing.com

For customer service and orders:
Toll-Free 1-888-313-2665

Visit us on the internet at http://www.arcadiapublishing.com

All images used in this title are from the Karen Kruse Collection unless otherwise noted.

Dedicated to my dad, who always taught me to be the best.

CONTENTS

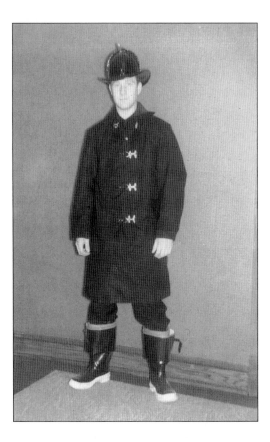

Here is Dad posing in his bright, new fire gear, in January of 1956, before any action. Notice how white the soles of his boots are!

FOREWORD

Some of my happiest memories are from my years playing football for the Chicago Bears for Coach George Halas at beautiful Wrigley Field. During that time in the 1960s, I had the privilege of visiting the Chicago Fire Department's Engine 78, the firehouse located across Waveland Avenue from the ball park.

Just as I always play hard to win and to be the best, so do these firefighters who dedicate themselves to the community they serve. Visiting the firehouse, I always received a warm welcome, a hot cup of coffee, and fascinating conversation. Other players, including fellow Hall-of-Famer Bill George, used to stop by occasionally as well.

A Chicago Firehouse: Stories of Wrigleyville's Engine 78 demonstrates joy, sadness, tragedy, and above all, courage and compassion. Karen Kruse's enthusiasm and dedication shine through as she lovingly captures the spirit and history of this unique piece of Chicago.

God bless you.

Mike Ditka
Former player and head coach of the
Chicago Bears

PREFACE

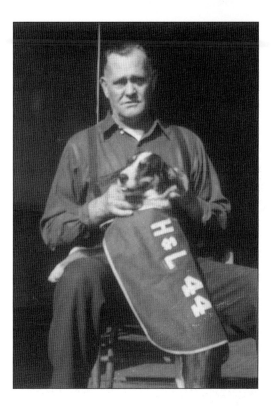

My grandfather, Robert C. Kruse, poses with Truck 44's mascot. He served at this firehouse from the time he came on the job in 1928, in the same candidate class as Robert J. Quinn, the future fire commissioner, until his retirement in 1949.

"Engine 78—Still Alarm. . . ." These words have been broadcast thousands of times over the speaker in Engine 78's quarters. This proud old firehouse has been home to some of the hardest working public servants in the long history of our fabled fire department. The unique location of Engine 78 and Ambulance 6 serves as a landmark for visitors from all over the country. A great meeting place for families enjoying a day at the "friendly confines," where the friendly spirit of the neighborhood heroes proudly show off the shiny red truck and the worn brass sliding poles!

The whole city welcomes the story lovingly told about a true Chicago hero—Engine 78's quarters.

Fire Commissioner James T. Joyce
Chicago Fire Department

ACKNOWLEDGMENTS

Before starting this book, I hadn't been inside the quarters of Engine 78 for nearly 30 years. Even though the firemen I knew as a child were long gone, the present members of the company opened up their hearts and house to me—and my labor of love. Unbeknownst to them, I did not come looking for an expose, yet they trusted me and gave of their time and energy. They made a little girl's fantasy come true . . . firemen really are members of the most trusted profession!

It is with great love and appreciation that I thank the Chicago Fire Department, especially Fire Commissioner James Joyce and the members of Engine Co. 78, from the "average" firefighter to the top brass. They were all extremely helpful and enthusiastic, and I am forever in their debt. I was taught as a child that if I ever needed help, firemen would always be there for me. They have come through beyond my wildest dreams. I have often said, "Firemen always treat me like gold," and they have proven that once again in magnificent style. Special thanks go to Captain Patrick Maloney and Marc Patricelli. Thanks, guys.

None of this would have been possible if I hadn't had such wonderful parents. How many kids have the privilege to grow up with such positive role models in their lives? My father is my hero, and I'm very proud to admit that. It is through the strength, determination, and courage that I learned from him that I was able to complete this book. Dad, I hope I have made you half as proud of me as I am of you . . . thanks. My mom has been there for me through thick and thin, encouraging and believing in me every step of the way. Mom, having your support is invaluable to me . . . thank you.

Very special thanks go to Mike Ditka, for taking the time from his busy schedule to acknowledge my labor of love and provide the foreword. You exemplify being the best. It is a privilege to have you introduce this tale of the hard-working members of Engine 78. . . thank you.

Of course, I need to thank a few other people for their love and support. Among them are Marilyn Inge, who originally encouraged me to write this book; Geraldine Kluszewski, who enthusiastically checks on my progress every week—without fail; Jim Mason, for believing all along that I could do this; and Don Beatty, for teaching me how to make my words flow.

I also want to thank those who applauded my victories and sympathized with my frustrations along the way, including: Fran Allen, Eleanor Anderson, Tom Bartkoski, Betty Benton, Jane Berman, Brian Bowman, Greg Crawford, Carol Goodman, Ellen O'Brien, Cindy Ogilvie, Tony Roma, Carol Romanow, and Nance Zeppos. Each one of you has a very special place in my heart.

I want to thank Christina Cottini, my publishing team at Arcadia Publishing, and everyone who helped make this project a success. I could not have done it without you. Thank you.

Lastly, I am indebted to St. Florian, the patron saint of firefighters, for protecting those I love and keeping them out of harm's way.

INTRODUCTION

History is best told by those who have lived it. My dad, Robert F. Kruse, had an exciting 30-year career with the Chicago Fire Department (CFD). This book is based on his first 14 years, spent at Engine 78, the Wrigleyville firehouse at 1052 West Waveland Avenue.

Dad went on the job January 16, 1956, reporting to the drill school—long before the present state-of-the-art fire academy was built—for basic fire training. One month later, on February 18, he reported to Engine Co. 78 to work in the "family" business. His father had also been a firefighter, coming on the job in 1928, in the same candidate class as Robert J. Quinn, the future fire commissioner. My grandfather was assigned to Truck Co. 44, their new house now located at 2718 North Halsted, and spent his entire 21-year career with this one truck company until his retirement in 1949. Firefighting really was the proud "family" business.

When I decided to write this book and follow in their footsteps in my own way, my dad fully embraced the idea and was eager to help. To stir his memory, we took out his scrapbook of newspaper clippings and memorabilia of fires he fought and disasters he experienced through the years. It became a marvelous resource and triggered many of his memories, both happy and sad, but all documented and true. Here was all the true-life drama a writer could ever hope for!

The fire stories presented here are seen through my father's eyes. He was there, so he should know! The research and

verification of facts are my own handiwork. I think we've made a pretty good team! Unless otherwise stated, these stories take place in the late 1950s through the '60s. This book is merely a slice of firehouse life during that dynamic time period. The neighborhood, however, remains timeless in its own special way. Just as my dad is uniquely qualified to act as an historical resource, so am I uniquely qualified to write this story.

The CFD has been in my blood literally since birth. Dad was already on the job over two years when I was born in June of 1958. Somehow, his career became my birthright . . . or was it just the fact that I'm Daddy's little girl?

Many incidents have occurred in my life directing me to this moment in time. When I was a little girl, my parents took me to see the 1961 movie, *Bachelor in Paradise,* starring Bob Hope and Lana Turner. In the film, Bob Hope is a famous writer posing as a bachelor in suburbia, and all the while he is actually doing research on the exploits of the neighbors—especially the housewives. The audience roars as he attempts in vain to do laundry, causing the washing machine to overflow and spewing massive amounts of soap bubbles everywhere. During the ensuing hilarity, the scene abruptly changes to show a bright, red fire engine streaking down the street, with sirens blaring, coming to the rescue. There I am, watching that show, proudly clapping at the tender age of three. I didn't understand the movie, but I certainly understood that fire engine.

A few years later, I received a dustpan and broom set, complete with a mini cardboard

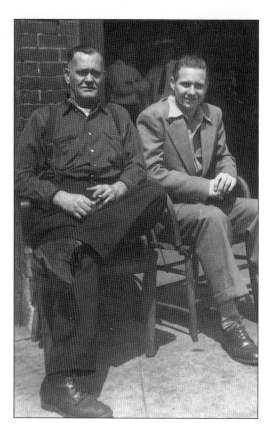

Here is Grandpa relaxing outside Truck 44 with his son, Robert F. Kruse (my dad), c. 1947.

I squealed with delight and loved the smell of that musty old fire engine. The front seat of the engine was cracked and ancient looking to me, but I would be content to just sit there forever . . . if I could. Later, at the ballpark, we would sit in left field's foul territory against the back wall just so that I could see that firehouse, ready if the boys got a run. When I heard sirens, I would jump up just in time to wave to the guys on the backstep as they flew down Waveland with their sirens screaming and lights flashing. The baseball games didn't matter, but that firehouse sure did.

This love affair with the firehouse has never ended. I always thought I was really lucky if Dad would forget something at home, like his eyeglasses or bed sheets, the morning he went to work. He would call my mom requesting that we make an emergency delivery of the missing item. Yippee! Then we would have to go to the firehouse. I was elated, as it meant another visit to that mystical place. It was a man's world in those days, and little girls were simply not allowed. I was happy to have any chance to glimpse their realm. . . even if just for a short while.

As I grew up, my fascination with the fire department took another form. In high school English class, each student was required to make an oral presentation to the entire class, based on an interview that we had conducted with the individual of our choice. The subject could be anything we wanted—from footballs to farming. The object was to know our subject well enough to be able to talk in front of the group for a solid five minutes. The thought of doing this terrified most of my classmates. Producing a written report besides doing the talk would award extra credit. I picked the Chicago Fire Department and interviewed my dad. My talk easily lasted 20 minutes! I spoke about ranks and insignia, fire procedure and districts. My 20 minutes seemed only an instant, and it was the most natural thing in the world to me. I had found a subject I loved! The written report was second nature, so getting that extra credit was a snap. It was the first

closet in which to keep them. (I guess my parents were trying to domesticate me!) One day, an elderly man was at the house visiting my father. I saw him drop ashes from his cigar onto our kitchen floor. Like a flash, I had them swept up and out of sight. I knew that ashes meant fire and needed to be taken care of immediately. While doing research for this book, my dad told me that man was Lester Harper, retired from Engine 78 on February 5, 1958—before I was born.

As a young girl, I was able to visit the firehouse on special occasions, like when we went to see a baseball game at Wrigley Field. Before walking across the street to the ballpark, I got to sit on the shiny fire engine and ring the silver bell on the front of the old rig. If I behaved, I'd get to blow the siren too!

time my two loves came together—the Chicago Fire Department and the written word.

I've been putting pen to paper for various reasons as far back as I can remember. Last year, this mighty combination came together again. An article I wrote about the firehouse and my childhood was published nationally to rave reviews from friends and family. It was then that I realized I needed to take my writing talent to a higher level and write this book. My two passions are together once again in this, my tribute to the magical place I fell in love with as a child.

I deliberated long and hard about how to showcase the material presented on the following pages. Do I pass it on as an impartial observer like a good reporter, or like the knowledgeable daughter of a 30-year veteran of the CFD? I have chosen the latter simply because I cannot do it any other way. I am very proud of my father and the members of the department. It's sad to note that in my dad's entire career of saving people and helping the public, only ONE person ever thanked him personally. This individual was the son of an elderly woman he rescued from a burning building. That one man took the time to find him after the fire was out to say thanks. Our firefighters deserve so much more, and it is my hope that this book can, in some small way, show our immense gratitude and appreciation of them all. Along with the factual information, I hope that my enthusiasm and love for the department shines through. It is with extreme pride that I give you . . . *A Chicago Firehouse: Stories of Wrigleyville's Engine 78.*

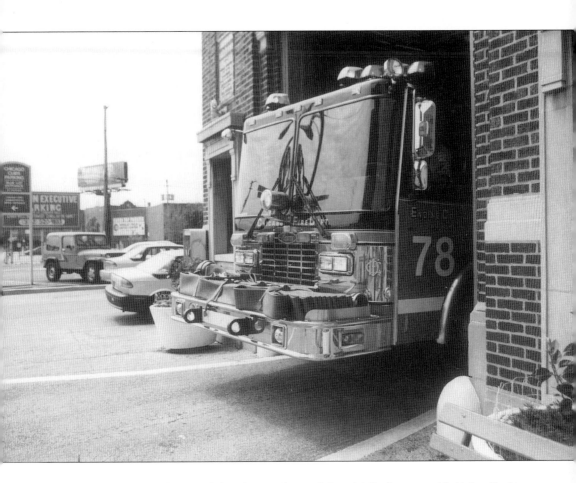

Here, the modern rig pulls out of the skinny door of the old firehouse, with lights flashing, heading to a run.

CHAPTER 1

THE LAKEVIEW FIRE
DEPARTMENT

Once upon a time is the way all good fairy tales begin, but this particular tale is true. It is the story of an American firehouse, the firemen who love her, and the area she serves. The knights on white horses in this epic are actual heroes riding a bright red fire engine when help is needed. This is the story of Engine Co. 78.

Often called the Wrigleyville firehouse, she is located directly across from the famed Wrigley Field, home of the Chicago Cubs baseball team. Located in the extreme left-field foul territory, she stands guard over the area. To understand her significance, we need to return to the beginning.

In the 1830s, Joseph Sheffield arrived here from Connecticut to establish a produce farm and nursery. On May 9, 1851, he purchased two 40-acre plots in the area we now know as Lake View. Directly to the south, Chicago was already a city, having been chartered in 1837.

At that time, it was customary to name a road after the family, so naturally Sheffield Avenue was born. The lake was much farther inland in those days, and Mr. Sheffield would get frustrated when the cross street through his property would become flooded by the inundating waters of Lake Michigan during bad weather. He aptly named this street "Wave-land" and thus created the corner of Sheffield and Waveland as we now know it. Today, high above the southwest corner of this intersection sits the majestic scoreboard and outer limits of beautiful Wrigley Field.

By 1857, Chicago was in need of heavier fire equipment as the city was growing steadily and needed protection, so the first pumper was purchased. Named after charismatic 6-foot, 6-inch mayor "Long John" Wentworth, the "Long John"—as she was affectionately called—would make a significant difference in firefighting efforts. It was the beginning of the modern era of firefighting in Chicago, but the fire department was still staffed only by a proud volunteer brigade.

That changed completely after the large fire at 109–11 Water Street on October 19, 1857. Twenty-three volunteer firemen and civilians lost their lives at that fire, precipitating change in the unorganized force. Mayor Wentworth is credited with founding our paid professional fire department.

On August 2, 1858, the Chicago Fire Department was born. An engineer was promptly hired to operate the "Long John" pumper, and the department was organized on a military basis as it is today. Not long after, our beloved water tower was built in 1865, and fire alarm boxes were installed. Chicago was truly on the map.

Meanwhile, Lake View was still growing and coming into its own. By 1865, Lake View officially became a town by an act of the Illinois General Assembly, and the community had its own post office by 1870. By then, Chicago was 6 miles long by 3 miles wide, with Lake View on the north and Hyde Park on the south.

On October 8, 1871, the unthinkable happened. The Great Chicago Fire started in Patrick and Catherine O'Leary's barn at 137 West DeKoven Street. Chicago had been suffering from a drought for 14 weeks. Everything was dry and dusty, including the dwellings, most of them made of wood. She was a giant kindling pile ripe for a spark to set her off. Legend has it that Mrs. O'Leary's cow started the conflagration by kicking over a lantern, but since the fire started about 9:25 p.m., it is doubtful that the cow did it. She would have been milked long before then and was probably sound asleep, as were the O'Leary's. The fire may have been started by an errant spark from a nearby chimney, as the homes were very close together, or it could have been a careless smoker. The fire spread quickly, aided by a dry, 25-mile-per-hour southwest wind.

Besides wooden structures, there were 561 miles of wooden sidewalks, 10 train lines all with wooden depots, 17 wooden grain elevators, and many wooden streets. Even the bridges were made of wood. There were

only 17 steam engines and 48,000 feet of hose available for the city. The department had wanted more but was denied. When *the* fire broke out, firemen were still trying to recover from a large fire the day before at a planing mill on Canal Street. Fought for over 16 hours, that fire consumed 4 city blocks before it was under control, and much of the fire equipment was damaged or rendered inoperable as a result.

As the fire raged northward, residents fled to Lake View. They were safe there, as the fire eventually only reached as far as Fullerton Avenue. People crowded into homes, and when there was no room left, they spilled out onto the prairie to the west of the city. The fire finally came to an end with the help of a steady rain two days later on October 10, 1871.

In its wake, an estimated 300 people lost their lives, 100,000 were homeless, there was over $300 million in property damage, and over 6-square miles of Chicago were in ruins. Due to the devastating nature of the blaze, future fire concerns swept through the city. Joseph Medill, then editor of the *Chicago Tribune*, was elected mayor as the "fireproof candidate," bringing with him reform to the building code. No longer would wooden structures be allowed inside the city limits.

This new code had a boom effect on nearby Lake View, as no such codes existed there. Property owners built as they chose, expanding Lake View until it was recognized as a city in 1887, being granted city status with seven wards.

Two years later, on June 29, 1889, the Chicago City Council voted on the annexation of Lake View, after the residents agreed by voting for the change. In one day, Chicago grew by 125-square miles, adding not only Lake View, but many other nearby towns as well. This historic area of the city is still referred to as Lake View or Lakeview.

Meanwhile, in 1884, the town of Lake View erected its firehouse at what was then 1692 North Clark Street. The city reorganized the street numbering system in 1908, so the same address today would be 3217 North Clark Street. The original firehouse was a one-story frame building, with one bay housing Hose Co. 4 and her team of horses.

Now part of the City of Chicago in 1894, the firehouse was physically moved to its present location at 1052 West Waveland Avenue, then known as 1306 West Waveland. A second floor was added around this time to accommodate the new engine company. On December 31, 1894, Hose Co. 4 was reorganized as Engine Co. 78, under the command of Captain George B. Miller.

This frame house served the community until 1915, when it was torn down to build the present brick version. It was decided that the engine company had to be relocated in the neighborhood in order to continue to serve the residents during the construction of the new firehouse. They were temporarily

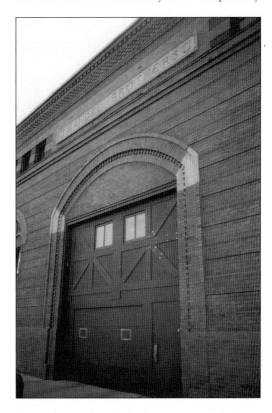

Engine 78 relocated to the Mandel Bros. Garage while their new brick firehouse was being built in 1915.

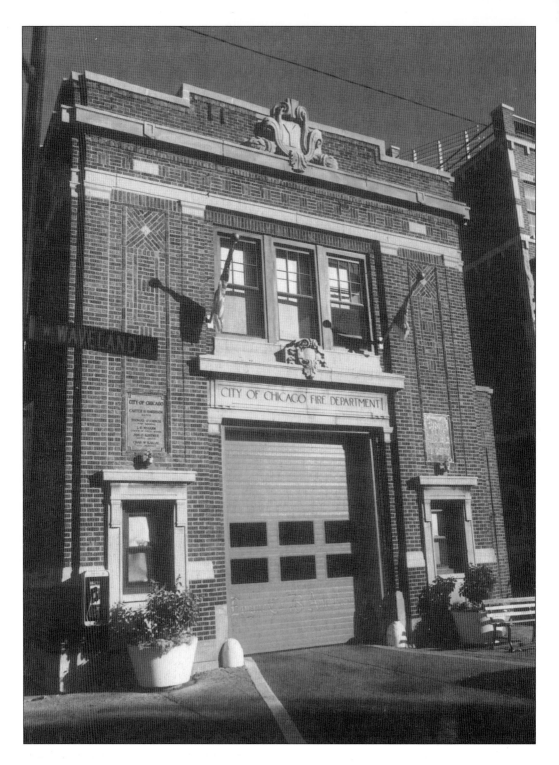

Engine 78's quarters stands today as she was built in 1915, at 1052 West Waveland Avenue in Chicago.

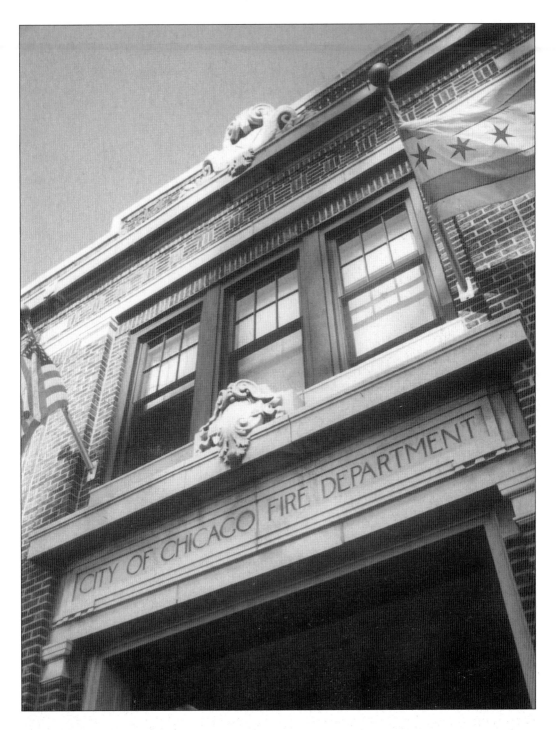

The details of Engine 78's house are impressive. Above the overhead door, two concrete medallions can be seen over the words, "City of Chicago Fire Department" boldly etched into the building's facade. Both the American and City of Chicago flags proudly fly outside the bunkroom windows.

relocated to the Mandel Brothers Garage on the southwest corner of Halsted Street and Aldine Avenue.

This beautiful masonry building was built in 1903 as a barn and distribution warehouse for the Mandel Brothers Department Store. Over the entrance door on the Halsted Street side, "Mandel Brothers" can still be seen etched in concrete. The Mandel Brothers establishment had its start as a dry goods store back in 1855, and it eventually became a rival of Marshall Fields. This particular warehouse served the need for Engine 78's relocation, as it was in the neighborhood and had ample room for fire apparatus.

During the 12 years between 1911 and 1923, the Chicago Fire Department became the first American fire department to become completely motorized. This move saved the city considerable money. Horses cost $285 each to buy and $3,621 a year to feed, compared to the $1,000 in maintenance costs per year for motorized equipment. Due to the quicker response times, $1 million in property was saved the first year. This new firehouse was built with the intent of using modern firefighting equipment since there is no hayloft and no stable in which to keep horses. By 1919, the two-platoon shift system was instituted, and kitchens were needed in all houses. This firehouse already had a kitchen, located directly behind the apparatus floor.

This firehouse stands today as she was built in 1915. Her painted red front door is narrow by modern standards, as only one piece of apparatus can emerge at a time. The modern door is an overhead design; however, the original version was of the "swing-out" variety. Directly over the door, carved boldly in stone, are the words, "City of Chicago Fire Department." Immediately over it sits an intricately carved stone medallion, very popular on buildings at that time. At each end of this concrete shelf proudly flies a flag—the American flag on the left and the City of Chicago flag on the right.

Near the roof sits another even larger medallion in the same style. Three windows on the second floor are located above the overhead door, and two more are located on either side of the front door. To the right side, around the corner of the building, is the pedestrian entrance door, which is also painted in fire engine red.

The building is a fine piece of architecture as the brown and red, textured and smooth brick used was laid out in a geometric design, creating fascinating patterns on the facade. The skill of the bricklayers is evident, as the corners of the structure appear gracefully rounded. She is 34-feet wide and 60-feet deep, with a southern exposure on Waveland Avenue. Directly across the street sits her slightly older neighbor, the famed Wrigley Field, built one year earlier in 1914.

Flanking the front door are two large metal plaques, each commemorating the time of her birth. On the left side, positioned over a green light, the plaque reads, "City of Chicago; Carter H. Harrison, Mayor; Thomas O'Connor, Fire Marshal; L.E. McGann, Comm'r of Public Works; Jos. O. Kostner, Deputy Comm'r; Chas. W. Kallal, City Architect." It is interesting to note that the sign refers to Carter H. Harrison II, but his father, Carter H. Harrison I, was mayor when the original frame house was built on Clark Street in 1884. There was a building boom in 1915, with twice as many public works projects being done that year as the year before. In addition to Engine 78's new quarters, seven other firehouses were also built in the city. Charles W. Kallal is listed as city architect on those as well. City architect was the title given to the architect working for the Department of Public Works. Kallal probably just approved the firehouse plans rather than actually designing it, but we do know that it was constructed at a cost of $18,600 by Austin J. Lynch Co.

Over a red light on the right side of the building sits the second metal plaque. It proudly displays, "Erected; A.D. 1915; for the City of Chicago Fire Department."

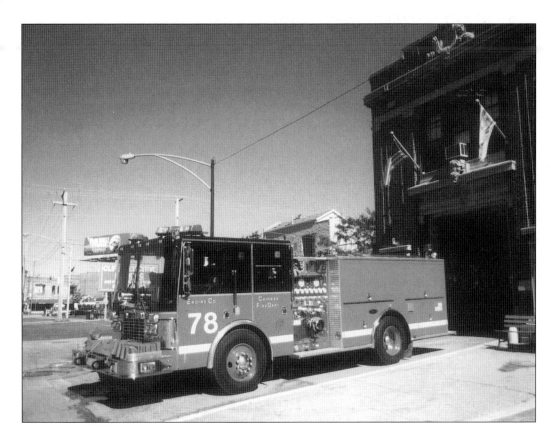

This is Engine 78 as she looks today, sitting on the ramp in front of the house, freshly washed on a sunny morning.

Chicago and some of her suburbs are amongst the only cities in the country in which red and green lights flank the front door, rather than the standard red or frosted white. Albert W. Goodrich, Fire Commissioner from 1927–31, is credited with creating this unique feature. At one time, he owned the Goodrich Transit Co., the largest of the Great Lakes steamship lines. Because of his shipping interest and love of the fire department, he ordered the red and green lights on the firehouses and apparatus, as those colors denote port and starboard on a vessel. In the 1927 *Report of the Fire Commissioner*, the lights are mentioned as a way, along with the bright red front doors, to make firehouses as conspicuous as possible. This enabled citizens in need of help from the CFD to easily identify them. The lighting scheme remains to this day on equipment and firehouses. The modern Engine 78 apparatus has a lone green light over the officer's side of the rig.

The neighborhood has changed over the years, but somehow it still fits together. Most of the homes along that block of Waveland have been torn down and rebuilt to ultra-modern standards, larger than their originals, but the new style of their designs still seems to match the firehouse on the corner. The same attention to detail and careful brickwork remain. She is the sentinel at the end of the block and has stood the test of time.

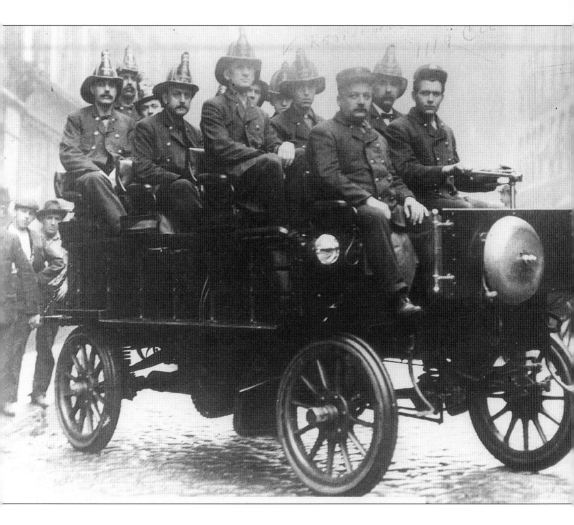

This is how the Insurance Patrol appeared in 1906. (Source unknown.)

CHAPTER 2

A CIVILIAN'S GUIDE TO
THE CFD

Before moving on with our story, it is my hope that the following information will both educate and enlighten you, providing background into the history and color surrounding the Chicago Fire Department and firefighting in general.

The Definition of a Firefighter

Webster's New World Dictionary defines a firefighter as "a person whose work is fighting fires." Technically, the definition is correct, but a firefighter is so much more.

Firefighting has been called the bravest, most respected, most noble, and most stressful profession. Firefighters are accountable and have specific responsibilities, but they work as a team to get the job done.

The following poem illustrates it best. It has appeared in Ann Landers' column several times, but unfortunately, the author is unknown.

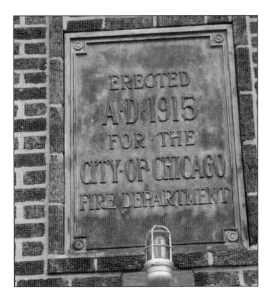

To the right of the front door, a plaque indicates that the structure was built for the City of Chicago Fire Department in 1915, and sits over a red light. The lights themselves represent port and starboard, just like on a ship.

What is a Fireman?

He's the guy next door—a man's man with the memory of a little boy.
He never got over the excitement of engines and sirens and smoke and danger.
He's a guy like you and me with warts and worries and unfulfilled dreams.
Yet he stands taller than most of us.
He's a fireman.
He puts it all on the line when the bell rings.
A fireman is at once the most fortunate and the least fortunate of men.
He's a man who saves lives because he has seen too much death.
He's a gentle man because he has seen too much of the awesome power of violent forces out of control.
He's responsive to a child's laughter because his arms have held too many small bodies that will never laugh again.
He's a man who appreciates the simpler pleasures in life. . .
hot coffee held in numbed, unbending fingers. . .
the flush of fresh air pumping through smoke-and-fire-convulsed lungs. . .
a warm bed for bone and muscle compelled beyond feeling. . .
the camaraderie of brave men. . .
the divine peace of selfless service and a job well done in the name of all men.
He doesn't wear buttons or wave flags or shout obscenities.
When he marches, it is to honor a fallen comrade.
He doesn't preach the brotherhood of man.
He lives it.

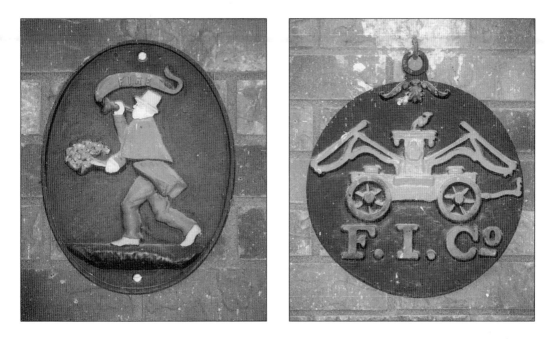

Here are examples of fire marks used in Colonial days. These indicated that the residence they were adhered to was covered by fire insurance and which insurance company would pay the volunteers if the building and property were saved from fire.

Why Firemen Wear the

Maltese Cross:

The Maltese Cross is recognized as the international symbol of firefighters. It has a round center with four lobes, one extending off to each side. This symbol is often seen printed with the bold black letters "IAFF" as a sticker on the back windows of vehicles. This is the official symbol of the International Association of Fire Fighters, proudly displayed by the rank and file everywhere.

The Chicago version has a red center with Chicago embroidered in white inside. The four lobes are white with red lettering and trim. "FIRE" and "DEPT." are written respectively on the top and bottom lobes, while a fire hydrant is pictured on the left lobe, and a ladder and pike pole set are pictured on the right side. Most American cities have adopted some version of the Maltese Cross as the symbol for their

firefighters, but the contents and colors vary.

Long ago a courageous band of crusaders known as the Knights of St. John fought a group called the Saracens for possession of the Holy Land. When these crusaders advanced to the walls of the city, the Saracens threw glass bombs filled with naphtha at the invading army. As the knights became saturated with this highly flammable liquid, the Saracens hurled a flaming torch into their midst. This caused the knights to burst into flame, sure to die excruciating deaths.

Sympathizers to the crusaders ran into this inferno, often trying in vain to save the crusaders from this horrible, fiery end. They were revered as heroes and as our first brave firefighters. Later they were given a much revered badge of honor, an award of a stylized cross looking very much like the Maltese Cross of today, as a tribute for their courageous actions.

For close to four centuries, the Knights of St. John lived on the tiny Mediterranean

island of Malta, located just south of Sicily, hence this special cross became known as the Maltese Cross.

The Difference Between a Fire Engine and a Fire Truck:

The basic difference between a fire engine and a fire truck is the fact that the engine pumps water to extinguish the fire, and the truck carries ladders for search, rescue, and ventilation. That is the short answer. . . let's look a bit more closely.

An engine company's primary mission is to extinguish the fire. The company is staffed by an officer (either a captain or lieutenant), one engineer, and three firefighters. The captain is the boss of the house (all shifts), and the lieutenant is the boss of that shift, or in the case of several pieces of apparatus in one house, he is the boss of the equipment he is assigned. Engine companies carry "hard suction" hose connections (those big, black hoses on the sides of the engine) to link up with the fire hydrant. In turn, various sizes of hose lines come off the engine to fight the fire. The engineer never leaves the engine. It is his job to "send the water" after the hook-ups are made, and to make sure that proper pressure is always maintained.

Fire engines can also be used to supply water from engine to engine (if a hydrant isn't nearby), to a snorkel, or anywhere water is needed. Fireboats are considered engine companies since they function as their land-based counterparts. The only fireboat still in service in Chicago is Engine Co. 37, the *Joseph Medill*, named after the "fireproof candidate" who became mayor after the Great Chicago Fire.

A truck company's primary functions include search, rescue, and ventilation. They ride with a company officer and four firefighters. Upon arriving at the scene, they immediately rescue victims and ventilate the roof by cutting a 10-by-10-foot hole in it. The public often mistakenly believes that ventilating the roof feeds the fire oxygen. It actually does the opposite. The ventilation process releases supercharged heat and gases caused by the fire and trapped in the attic, making it easier to cool the fire. If these gases re-ignite, a "backdraft" situation can occur.

The term "hook-and-ladder" (H&L) company will often be used to describe a truck company. The term stems from Colonial days, when our early settlers built their homes with thatched roofs and dried mud lining their wooden chimneys. These homes were extremely prone to fire. A burning ember would often land on the thatched roof, starting a fire, or mud would flake off the chimney, causing the wood to ignite. If not detected immediately, the house would easily be destroyed. A 12-foot pole with a wet swab at the end (like a giant cotton swab) was used to put out these burning embers. A ladder was usually necessary to reach the spot of the fire. However, if it got out of hand, one home after another would be consumed quickly due to their closeness and the flammable nature of the building materials. To stop the spread of the advancing fire, a large hook attached to a chain or length of rope was used to pull down the next house in the fire's path as a firebreak. The owners had no choice if the town decided the house needed to be destroyed to save the remaining ones. The fire would run out of fuel (wooden chimneys and thatched roofed homes) and could be easily controlled and extinguished.

The early firemen ran to fires carrying these hooks and ladders until apparatus was developed to carry this equipment for them; thus the first "hook-and-ladder" companies were born.

The History of the Fire Mark and Fire Patrols:

Used in Colonial America, a fire mark was a plate attached to the side of a structure to indicate that the building was covered by fire insurance. A variety of materials were used to create these plates over the years, but oftentimes they were poured in lead or cast iron. Each insurance company had its own colorful design and paid the first volunteer company who responded to a fire at that location in proportion to the property that they were able to save. Competition was fierce among the many volunteer fire companies to get paid for their work by the insurance company. This both helped and hindered their efforts, as often fights would break out between the fire companies while the property burned. The idea was that by paying the fire brigade to save the property, insurance losses were kept at a minimum. For the most part, it worked.

The Home Fire Insurance Co. was established in 1871, but everything was destroyed by the Great Chicago Fire the next week. By 1875, the Fire Patrol was reorganized and doing quite well, often saving the fire insurance companies enormous amounts of money through their salvaging efforts.

In 1927, the two existing fire patrols responded to 3,065 alarms, logged 5,279 miles, replaced 317 sprinkler heads, installed 512 roof covers for temporary roofing, and placed 7,237 covers over property threatened by water damage. In 1928, they boasted the opening of a third house, located conveniently between the first two at 100 South Desplaines Street. It used a two-platoon system, consisting of 34 men working 12 hours each per shift. They had two salvage trucks and enough storage space for 600 covers. Their new location had room to dry 90 covers in 15 hours, or up to 180 covers over a longer period of time.

When my dad came on the job in 1956, Fire Patrols still existed with their easily recognizable red helmets, but they were on the wane. By 1958, only one unit remained, but it was soon phased out as the insurance companies did not want to pay them anymore. The fire department then took on these salvage duties.

Why We Call Them "Fire Plugs"

In the early 1800s, water lines made of pine were installed underground to serve the community for its water needs. In case of fire, a hole was chopped through the street, and then a 3–4-inch hole was bored through the main. The hole would fill with water where it was drafted out to fight the fire. To seal these holes after the fire, wooden plugs were used, hence the term "fire plug." The volunteers could easily tap into the water supply to feed their equipment and fight the fire. This led to the development of "hose companies," which carried the extra hose needed by the early steamer engines to fight fires. Eventually, the hose companies merged with the engine companies to become one unit, combining the ability to produce sufficient water pressure to fight the fire and carry the necessary hose, just as Hose Co. 4 became Engine Co. 78. Hydrants were installed when the pressure became too great for the simple system.

Why the Fire Academy is Significant to Chicago:

The present site of the Robert J. Quinn Training Academy has quite a fascinating history, probably the most significant of any building in Chicago.

On March 24, 1864, Patrick O'Leary bought a small cottage and parcel of land for $500. On October 8, 1871, it became the most famous piece of real estate in Chicago, as the place where Catherine O'Leary's cow supposedly kicked over the lantern to start the Great

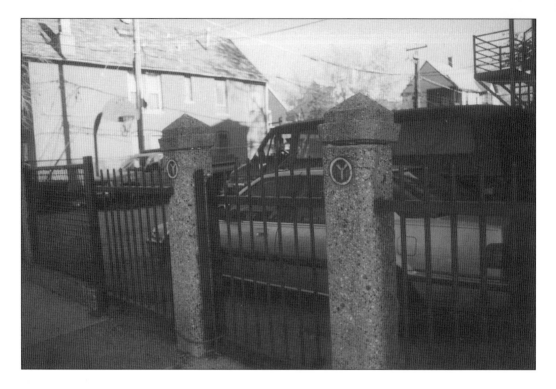

Two posts stand behind the firehouse, marking what used to be a gate.

Chicago Fire. Their address under the old house-numbering system was 137 West DeKoven Street. The two-room, ramshackle, weather-beaten cottage survived the devastating holocaust. The fire traveled 3.5 miles northeast but never moved 40 feet west.

On December 9, 1879, a mere eight years after the fire, the O'Leary's sold their property to Anton Kolar and his wife. They erected a large, two-story brick house with a smooth sandstone front the next year. The house was quite stylish for the time, but through time it has became known as the "forgotten house," as only the O'Leary cottage is remembered to have stood here. Shortly after it was built, the Chicago Historical Society imbedded a marble tablet in the front of the house as an attempt to preserve the site's history. It read, "The Great Chicago Fire of 1871 Originated Here and Extended to Lincoln Park. The Historical Society, 1881."

In 1928, the house was sold to the city for $36,000. The city council proposed that a memorial firehouse be built on the site, but the Great Depression began, and the funding for the new project never arrived. The city rented out the property to tenants for years. In 1937, another marker, this one of bronze, was added to the house to celebrate the hundredth anniversary of Chicago's incorporation as a city. Over time, the homes in the area became dilapidated and in need of major repairs. Eventually, the city ended up owning the whole block and decided to build a state-of-the-art fire academy on the site instead of the originally proposed firehouse.

The $2.5 million training complex was dedicated May 1961, and is the most modern fire training facility in the country. Chicago has extended her hand to her neighbors, and many suburban fire departments receive their training here as well. Today, the address is 558 West DeKoven Street. Prior to the academy,

the drill school at 720 Vernon Park Place served to educate new firefighter recruits. That site was torn down in order to make way for the Dan Ryan Expressway (I-90 and I-94).

Sculptor Egon Weiner created the "Pillar of Fire" figure in 1961 to grace the outside of this impressive complex. The academy was designated a Chicago Landmark on September 15, 1971, almost one hundred years to the day after the disastrous fire. It was renamed the Robert J. Quinn Training Academy on June 14, 1978, two months after Quinn retired as fire commissioner.

Robert J. Quinn was our most colorful fire commissioner, retiring April 1, 1978, after serving almost 50 years on the fire department, 21 of them as commissioner. He brought with him a competitive spirit and was known as an avid handball player, and also for his many improvements to the department, including development of this facility. He went on the job in 1928, in the same candidate class as my grandfather, and he was appointed commissioner by Mayor Richard J. Daley in February 1957. Quinn was respected in the department and won the Lambert Tree Award for heroism as a firefighter in 1934. Easily recognizable under his trademark crooked white helmet, he was revered as a "fireman's fireman," referring to firemen as a different breed and classifying them with the greatest of men. After noticing how the city trimmed its trees with their "cherry-picking" equipment, Quinn hit upon utilizing the same idea for firefighting. He is credited with the invention of the snorkel, so named by Chicago's press after it was put into service at a large fire in a lumberyard in October of 1958. Chicago was the first fire service in the country to use this versatile piece of apparatus, and it has proven itself time and time again.

The Robert J. Quinn Training Academy is a fitting tribute to this inspirational leader. Ironically, Chicago's Great Fire of 1871 instilled in Chicago a "can-do" spirit, ultimately producing the greatest fire department in the world.

Why Fire Codes Changed

Three fires stand out in Chicago history for contributing to the most major change in fire codes. They are the Great Chicago Fire, the Iroquois Theater Fire, and the Our Lady of Angels School Fire.

We've already discussed the Great Chicago Fire of 1871 and its massive destruction of life and property. Fire codes were changed to no longer allow wooden structures to be built within the city limits. It was hoped that this change would prevent a citywide disaster of this magnitude from ever occurring again.

This is why we celebrate National Fire Prevention Week during the week of October 9. On the fortieth anniversary of the Great Chicago Fire, the National Fire Protection Association (NFPA) decided that this anniversary should not be observed with festivities, but instead to inform the public of the importance of fire prevention. In 1925, President Calvin Coolidge proclaimed the first National Fire Prevention Week to be observed October 4–10. It has been observed nationally ever since.

The Iroquois Theater, located on Randolph between State Street and Dearborn, was only five weeks old when fire broke out during a matinee presentation of *Mr. Blue Beard* on December 30, 1903. The theater was a beautiful work of art in mahogany and marble.

The Iroquois was advertised as "absolutely fireproof," but this proved not so when a malfunctioning arc light ignited the muslin curtains of the stage during the second act of the play. The stage crew tried in vain to lower the fireproof curtain to separate the fire from the audience, but the cheap wooden tracks caused it to jam.

Due to the Christmas holiday, many children were out of school and were taken to the play for a treat. The 1,900 women and children in attendance were urged by lead actor Eddie Foy to remain calm and stay in their seats, but everyone fled when the stage

collapsed. The crowd ran terrified to the exit doors only to find many of them locked. Those that were unlocked opened inward, causing those in the front to be trampled to death by the weight of the others frantically pushing in their panic to escape. Six hundred and one women and children died as a result.

The tragedy caused fire safety standards to be changed nationwide; exits had to be clearly marked, and doors had to be able to be opened outwardly from the inside at all times.

More children lost their lives on December 1, 1958, just after 2:00 p.m., when the Our Lady of Angels Catholic School at 909 North Avers caught fire. The fire was set in a garbage can under a stairway. The stairwell acted like a chimney, quickly sucking the flames and smoke upward, bypassing the first floor where heavy wooden doors were shut, to the attic-like space, known as the cockloft, above the second-floor ceiling. The children and nuns were trapped. By the time they realized there was a fire, it was too late.

Unable to breathe due to dense smoke, many jumped from the high second floor, breaking bones but saving their lives. Many of their classmates were overcome by smoke and died at their desks, having been told by the nuns to stay in their seats and pray.

The fire department was hampered from the beginning, as they were initially given the address of the parish church at 3808 West Iowa, rather than the north wing of the U-shaped school on Avers. Extra alarms were immediately sounded to get all available fire apparatus and ambulances into the area. Ninety-two children and three nuns lost their lives, but due to the heroic actions of firefighters and civilians, 160 children were saved.

In 1959, the *Municipal Code of Chicago* was changed regarding fire codes for schools. Among the changes were the installation of sprinkler systems, fire doors at strategic locations, and automatic internal fire alarm systems linked directly to the fire department in all schools.

These fires were all tragic events in the history of Chicago, but perhaps because of them, the Chicago Fire Department has evolved into the proud and efficient organization it is today.

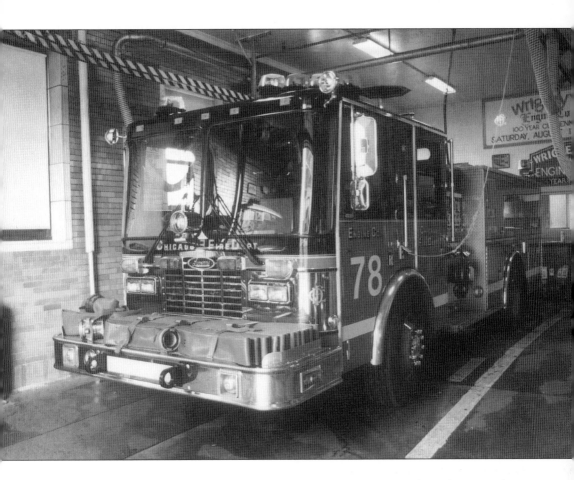

Obviously, the engine is the most notable feature of the house. The yellow plug gives the rig power while she is at rest so that the on-board computer doesn't drain the battery.

CHAPTER 3

A TOUR OF ENGINE 78

Engine 78's men live in a firehouse. It will never be a fire station. These men live there 24 hours at a time, no matter what, day in and day out. They eat and sleep together; they share their celebrations and sorrows together. They work through physical ailments like migraines, the flu, or stomach cramps, and mental conditions such as grief, anger, frustration, or worry. Unless confined to a hospital bed or laid-up in a cast, they are there, always ready.

In the scheme of the CFD, Engine 78 was assigned to the 13th Battalion of the 3rd Division. In April of 1980, seven divisions were reorganized into six districts. The old Division Marshall rank was replaced by the District Chief.

In 1956, the 13th Battalion consisted of Engine 78, Engine 55 and Truck 44, located at 2740 North Sheffield, Engine 56 at 2214 West Barry Avenue, Truck 21 at 1501 School Street, and Engine 112 at 1732 West Byron.

Engine 78 was division headquarters until 1948, an unusual choice since 78 was and still is one of the few houses without a separate officer's quarters. The Division Marshall slept in the bunkroom with the men. The situation was remedied when division headquarters was moved to Engine 112's house, which now shares its new quarters with Truck 21 at 3801 North Damen.

Sharing 78's quarters since its inception in 1928 is Ambulance 6, the only ambulance unit of the original six still at its premiere location. Long before paramedics, firemen worked both the fire apparatus and the ambulance. Some naturally were more suited to one than the other, but they were assigned to the ambulance just as any other company assignment made by headquarters. The officer in charge could reassign men from the engine to the ambulance if there was a shortage of personnel due to furloughs or some other reason.

The officer's desk on the first floor is where all runs are received and recorded. The Marshall Line (a red phone) connects firehouses to each other and to the Fire Alarm Office.

My dad has always been an engine man. He enjoyed rushing into the fire to extinguish the blaze, and he was good at it. Capt. Geoffrey Gibbons was an old-time Irishman, with hands as big as hams. He hailed from County Mayo in Ireland, had a thick crop of white hair, spoke in a stern voice, and always sounded like he was shouting in his booming Irish brogue. As a little girl, he terrified me. I was afraid of this large, loud man as he'd bellow, "Hiya, honey," every time he saw me. He would often advise my dad in his forceful voice, "Kruse, if you're doing a good job, let 'em know you're there. If you're screwing it up, keep quiet!" Dad learned a lot from the wise old captain, and the captain was happy to have Dad on his engine.

Jimmy Stewart was also perfectly placed in his normal ambulance assignment. A thin man who always wore a sweater, Jimmy had a gentle demeanor and was extremely patient with people. After working on a victim who didn't make it, he would often make the person more presentable, covering him up or wiping blood away before allowing the relatives in the room to see him. Jimmy cared about people, and he did more than just ambulance runs. One Easter Sunday when I was a little kid, my mom and I were waiting for a bus on our way to the firehouse to surprise Dad. Seemingly out of nowhere, the ambulance suddenly pulled up as it was returning from a run. Stewart, recognizing us, asked if we were headed to the firehouse. When he found out that we were, he told us to hop in. This was the old sedan type of ambulance with the slick red body and contrasting black roof—they looked like colorful hearses. We squeezed in the front seat with him and the other fireman. Imagine my dad's surprise when we popped out of that ambulance after backing in at the firehouse. People helped people, and firemen were no different. They still go out of their way to help.

In the old days, only one shift of firemen existed. They had to live in the neighborhood and got an hour off for lunch and a half-hour off for dinner to go home for a hot meal. They took turns signing the book as they left the house and again when they returned. After working six days, they received one day off.

On April 1, 1917, the two-shift system was implemented. Guys could now live further away, and firehouses that didn't have kitchens had to have them installed. This is the time when firehouse cooking really began. It was also during the turnover from the horse-drawn apparatus of the old department to the motorized vehicles of the modern era. Remember that by 1923, the CFD was completely motorized.

Under the two-shift system, the men worked 24 hours and then had 24 hours off. Eventually, "Kelly Offs" were instituted, giving the men their tenth working day off—in effect giving them three days off in a row every few weeks. The "Kellys" were named for Chicago's 37th mayor, Edward J. Kelly, who served in office from 1933 to 1947.

Even though they were permitted to live further from the firehouse, many of 78's men were neighborhood boys. Anthony (Tony) Tossi and his son, Tony Tossi Jr. were both assigned to Engine 78 at different times and both lived on Marshfield, right in the neighborhood. Firefighter Hossenfluke was a classic fireman in the old-world tradition with a tremendous handlebar mustache. He lived about a block away on Seminary. When he retired, he offered to sell his rare all-leather fire coat. He and his coat were both relics of days gone by.

By the 1950s, this had not changed much. Firefighters Eddie Krey and Johnny Bray were also neighborhood boys, but of the next generation. Many of 78's firemen went to Lake View High School on Ashland and Irving Park Road, located in the district. Engine 78 has always been a true neighborhood firehouse.

On December 16, 1955, the Chicago Fire Department changed to the three-platoon system, and more men were needed to fill

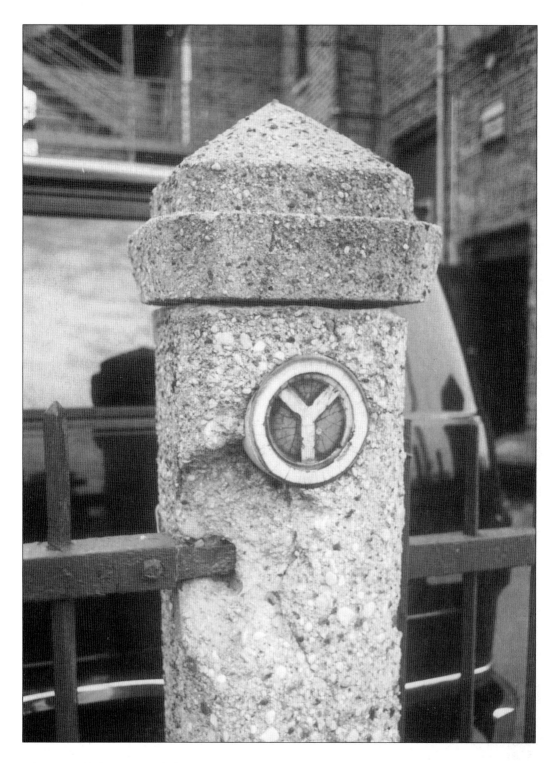

This City of Chicago symbol means "commerce" and represents the Chicago River. It can be found on many old municipal structures, such as Navy Pier.

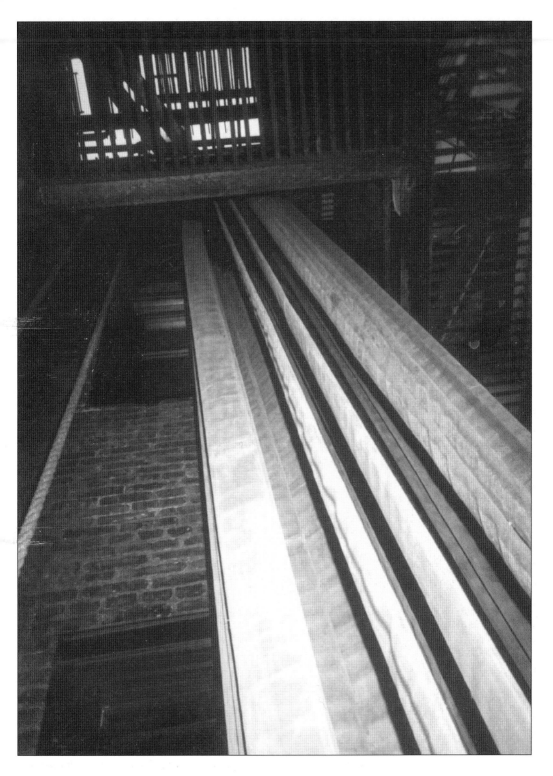

The hose tower is still used today to dry the cotton-jacketed hose.

positions. Now they worked 24 hours on, then had 48 hours off. It was during this time that my dad was hired, just in time for the January 16th candidate class of 1956. Hoping to stay in the 13th Battalion as his father had done on Truck 44, Dad was happy to report to Engine 78 on February 18, 1956, after his training was completed at the drill school. His starting salary was $4,554 a year, paid twice a month. After deductions, his first paycheck was a paltry $147.74.

For years, firemen worked the new three-platoon shift system without extra days off, except for their furloughs and their normal two days off after working one. Similar to "Kellys," "Daley Days" were named for former Mayor Richard J. Daley, and allowed regularly scheduled additional days off. There have been various versions of "Daleys," but currently after four working days, the men get their fifth scheduled working day off, giving them five days off in a row every few weeks.

The Chicago Fire Department has undergone many changes in its glorious history; regulating shifts was just one of them. Another has been the evolution of fire equipment. During the late 1950s, fire department hip boots as you know them were not yet the norm. Many of the guys wore ankle-top shoes. In fact, boots were discouraged and regarded as unmanly. When the Division Marshall came into the house and noticed boots lined up, he would kick them under the engine. That practice came to a screeching halt after a fireman was electrocuted when he touched a hot wire while standing in a foot of water during a basement fire. Soon, the order was released— boots were to be worn by all fire personnel.

The fire department was coming of age, and adjustments were being made. My dad's helmet, made of leather, cost him $21.50 in 1956. Compare that with the new, improved, safer helmet now running $238! They may be safer, but they just don't have the same character as the classic old helmets.

The fire coat has probably taken the most

noticeable jump in price and advanced the most in fire protection. Dad's original fire coat cost him $28.50. Today's sophisticated version is priced at $722.56. In the old days, before fire coats became mandatory, Dad used to wear an Army field jacket dyed black. The fire coats were heavy and too hot in the summer, but they did protect well against fire. It didn't take long before everyone was instructed to wear them, whatever the season.

The work pants of the 1950s were described as 100-percent wool serge trousers, and cost a mere $12.95 per pair. Today's counterparts look very much the same, but they now include a flame-retardant feature. The Flamex II Valzon pants sell today for a whopping $51.50 a pair. Fireproof pants used at night to help a fireman get dressed in a hurry, known as "bunkers," were a bargain at $18.50. They consisted of short fire boots with baggy fire-resistant pants attached, all held up with suspenders. Bunkers were carefully laid out by their bunks with the suspenders laid off to one side and the pants draped around the boots. When the alarm came in the middle of the night, firemen could easily swing their legs into their bunkers, grab the suspenders to hoist them up in one swipe, then slide the fire pole. Arriving at the engine, they grabbed their coats and helmets, jumping on the backstep of the rig as it headed out the door. Today bunkers are all but gone. Men now wear department issued "jammies," and have to throw on regular pants when summoned in the middle of the night, then they ride inside the engine on the way to the run. Gone is the romance of holding on tight while perched on the backstep as the engine flew out the door.

As with fire equipment, the firehouse has gone through some changes of her own. She burned coal for heat until the late 1960s, and it was up to the firemen to keep her fires stoked and the house warm. It was the responsibility of the man coming on watch to check the coal supply and to make sure the

boiler was adequately stoked for their steam heat and hot water. The man going off watch would wait at the top of the basement stairs listening for runs to come in, while the oncoming man performed his furnace duties before taking over on watch.

As you can see, there have been quite a few changes regarding many aspects of the fire department over the years, but sometimes the more things change, the more they stay the same. Some features of Engine 78's firehouse have endured for decades, like the "X" and "Y" symbols found around the house. In this case, "X" literally marks the spot.

Engine 78 has a 14-foot ceiling over the apparatus floor. The old, round light fixtures used years ago needed to be cleaned regularly due to trapped bugs and dirt. It took a bit of skill to position the 12-foot ladder directly under the dirty globes every month. Usually the ladder was either placed too far in one direction or the other, but that was not apparent until someone climbed the ladder and found it was misplaced. Frustrated by this, Firefighter Hossenfluke, mentioned earlier, chiseled an "X" into the concrete floor directly under the ladder when it was finally set in the correct position. Placing the ladder over each "X" guaranteed that it would be perfectly positioned under the fixture for retrieving, cleaning, and replacing the glass globe without any hassle.

The old round globe light fixtures are gone, but the electrical plates marking their original locations can still easily be seen on the ceiling between the modern rectangular fluorescent light fixtures. The X's are also there, each about the size of a quarter, still etched into the original cement floor. Finding those X's was a personal thrill for me. Standing on an "X" and gazing upward, I

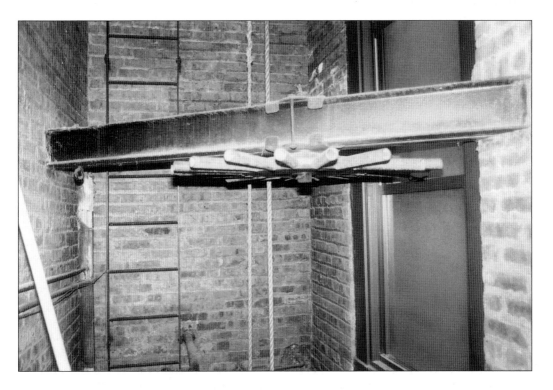

The hose is hung in the tower from this wheel-like apparatus, located at the second-floor level. Note the skinny, metal ladder in the background. This is the only way to access the roof.

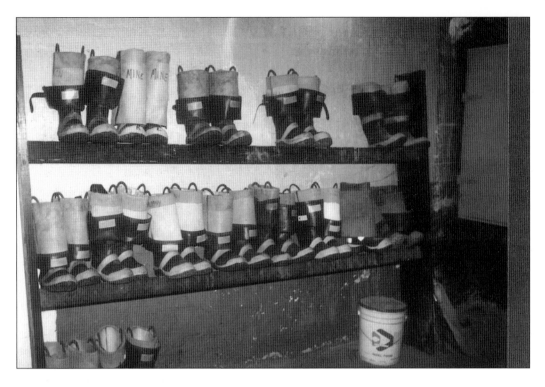

The bench of boots and rack of fire coats, located in the firehouse basement, hold equipment for the other two shifts not on duty.

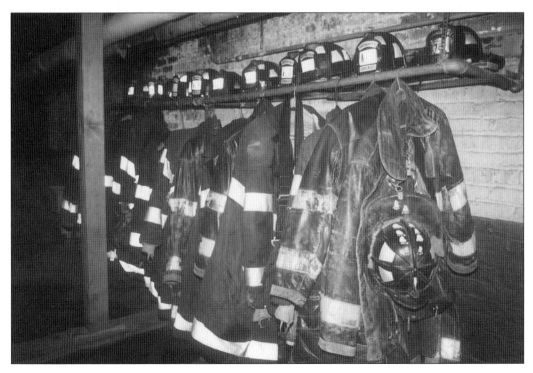

got chills as I discovered the ancient round plate still marking the spot of the original fixture. To realize that these X's have remained here for more than 50 years is truly astonishing.

By contrast, the "Y" symbol is much easier to find, but its past may not be quite as colorful as the "X." The best representation of the "Y" is located on what once was the back gate of the fence now surrounding the firemen's parking lot. On either side of this old gate sits a concrete post with a colorful round ceramic-like symbol of a white circle with a white "Y" shape inside it on a field of blue. The design represents the Chicago River and means commerce. This City of Chicago symbol was placed on many municipal buildings built by the Department of Public Works, and it can also be found on older bridges and public buildings such as Navy Pier.

At one time the symbol was inverted, with the vertical stripe on top. No one is quite sure why it changed direction, but speculation reveals that it might have been modified to this form to correspond with the reversal of the flow of the Chicago River, but this is not certain.

The gate containing the "Y" symbol has been there since the house was built, but the actual backyard has gone through some changes over the years. At one time, it was an actual backyard—complete with a lawn, trees, and flowers. Lt. Marshall used to maintain a compost pile in the southeast corner of the yard up against the firehouse. Here, used coffee grounds and other organic material was thrown to be used later as fertilizer. He used to lean out the second-floor window over the yard to direct the firemen in laying old garden hose to form a graceful contour border around his flower bed. It was truly a work of art. Over time, the backyard became a paved parking lot for the firefighters, as parking in the Wrigleyville area became increasingly scarce.

Moving inside through the back door brings us into the kitchen. Just like the parking lot, this room has seen its share of changes. Here three shifts of men share cooking equipment and facilities. This is the hub of the firehouse, and the place where meals and conversations are shared. Coffee is still the mainstay of the fire department, and a fresh pot is always on hand for visitors and firemen alike.

A windowed wall now separates the kitchen from the apparatus floor, with a doorway at either end. However, the wall from about 3 feet up used to be made entirely of screen, giving the kitchen a porch-like feeling. Walking out of the kitchen, the engine sits on the right (west) side of the apparatus floor, and the ambulance is on the left (east). Both face the single overhead door to the south.

In the northeast corner, behind the ambulance, stands the historic hose tower. From the outside it looks like a chimney, although four times the normal size. The tower is still used to dry the woven cotton-jacketed hose used to fight fires. The hose is rubber on the inside, but the outside has a canvas-like covering. Pure rubber hose, by contrast, does not need to be dried but is generally only used to hook the engine up to the hydrant, known as the soft suction. The old soft-suction hose was just a larger version of the same cotton-jacketed hose used in firefighting. My father would often be given the job of cleaning the soft-suction hose so the engine looked great for inspection. He would get on his hands and knees and scour the hose with lye soap using a scrub brush until it was beautifully clean.

In my dad's time, two beds of hose were carried on the engine. One side carried 2 1/2-inch hose and the other carried 3-inch hose. One day every week was designated "hose day." One week, the 2 1/2-inch bed was emptied, swept out, and rearranged; the next week, it was time for the 3-inch bed. Today the engine's hose bed is divided into three sections—700 feet (fourteen 50-foot lengths) of 2 1/2-inch hose are carried on each outer bed, while 700 feet of 4-inch pure

A quarter is used to show the size of the X's etched into the apparatus floor. Directly overhead, the old, round light fixture plate is still visible next to the modern lighting. The X's helped to position the ladder so that the globes of the round fixtures could be easily cleaned every month.

got chills as I discovered the ancient round plate still marking the spot of the original fixture. To realize that these X's have remained here for more than 50 years is truly astonishing.

By contrast, the "Y" symbol is much easier to find, but its past may not be quite as colorful as the "X." The best representation of the "Y" is located on what once was the back gate of the fence now surrounding the firemen's parking lot. On either side of this old gate sits a concrete post with a colorful round ceramic-like symbol of a white circle with a white "Y" shape inside it on a field of blue. The design represents the Chicago River and means commerce. This City of Chicago symbol was placed on many municipal buildings built by the Department of Public Works, and it can also be found on older bridges and public buildings such as Navy Pier.

At one time the symbol was inverted, with the vertical stripe on top. No one is quite sure why it changed direction, but speculation reveals that it might have been modified to this form to correspond with the reversal of the flow of the Chicago River, but this is not certain.

The gate containing the "Y" symbol has been there since the house was built, but the actual backyard has gone through some changes over the years. At one time, it was an actual backyard—complete with a lawn, trees, and flowers. Lt. Marshall used to maintain a compost pile in the southeast corner of the yard up against the firehouse. Here, used coffee grounds and other organic material was thrown to be used later as fertilizer. He used to lean out the second-floor window over the yard to direct the firemen in laying old garden hose to form a graceful contour border around his flower bed. It was truly a work of art. Over time, the backyard became a paved parking lot for the firefighters, as parking in the Wrigleyville area became increasingly scarce.

Moving inside through the back door brings us into the kitchen. Just like the parking lot, this room has seen its share of changes. Here three shifts of men share cooking equipment and facilities. This is the hub of the firehouse, and the place where meals and conversations are shared. Coffee is still the mainstay of the fire department, and a fresh pot is always on hand for visitors and firemen alike.

A windowed wall now separates the kitchen from the apparatus floor, with a doorway at either end. However, the wall from about 3 feet up used to be made entirely of screen, giving the kitchen a porch-like feeling. Walking out of the kitchen, the engine sits on the right (west) side of the apparatus floor, and the ambulance is on the left (east). Both face the single overhead door to the south.

In the northeast corner, behind the ambulance, stands the historic hose tower. From the outside it looks like a chimney, although four times the normal size. The tower is still used to dry the woven cotton-jacketed hose used to fight fires. The hose is rubber on the inside, but the outside has a canvas-like covering. Pure rubber hose, by contrast, does not need to be dried but is generally only used to hook the engine up to the hydrant, known as the soft suction. The old soft-suction hose was just a larger version of the same cotton-jacketed hose used in firefighting. My father would often be given the job of cleaning the soft-suction hose so the engine looked great for inspection. He would get on his hands and knees and scour the hose with lye soap using a scrub brush until it was beautifully clean.

In my dad's time, two beds of hose were carried on the engine. One side carried 2 1/2-inch hose and the other carried 3-inch hose. One day every week was designated "hose day." One week, the 2 1/2-inch bed was emptied, swept out, and rearranged; the next week, it was time for the 3-inch bed. Today the engine's hose bed is divided into three sections—700 feet (fourteen 50-foot lengths) of 2 1/2-inch hose are carried on each outer bed, while 700 feet of 4-inch pure

A quarter is used to show the size of the X's etched into the apparatus floor. Directly overhead, the old, round light fixture plate is still visible next to the modern lighting. The X's helped to position the ladder so that the globes of the round fixtures could be easily cleaned every month.

rubber hose is carried in the center bed. The 3-inch hose is not used anymore, except for use on some trucks' aerial ladders.

After fighting a fire, a fireman still has a lot of hard work to do. A dry 50-foot length of 2 1/2-inch hose weighs 56 pounds, and a 50-foot length of 3-inch hose weighs more at 64 pounds, but they both weigh even more when wet.

Wet hose is picked up and brought back to the house where it is hung up to dry, literally. Without this process, the hose would mildew and rot over time. A rope system is used to hoist one length of hose up about 25 feet inside the tower to the second floor, where it is unhooked and laid over one of the 16 spokes attached to a wheel-like holder. The hose is sent down the other side until it reaches the starting point, thus a 50-foot length of hose is now hanging from its middle with 25 feet of it hanging on either side of the spoke. This is repeated for every length of hose used at a fire. Cotton-jacketed soft-suction hose did not need to be dried in the tower, as it was exposed on the rig and dried naturally. The wet hose is left in the tower to dry, usually overnight, then is taken down and placed on the rack used to store extra hose. When firefighters come home with wet hose, it is replaced on the engine with dry hose removed from this rack so that they are always prepared for the next run. However, during a busy day, especially with the old configuration of hose, they could run out of dry hose to keep on the engine. When this happened, dry hose on hand was placed first in the hose bed at the bottom. The driest of the remaining wet hose was laid on top, so the engine was always carrying its full capacity of hose. The wet hose was always replaced with dry eventually.

Each length of hose is numbered. For example, if Engine 78 started out with 15 lengths of hose, these numbers would most likely range from one through fifteen. Over time, hose lengths are replaced due to breakage and other problems. Hose numbers are never reused, so the next length number would be 16 in our example. By now, Engine 78 could be numbering in the hundreds. These numbers are stamped directly into the brass fittings at either end of each 50-foot length. A white stripe is painted on one end of the outside of the hose, a few inches from the butt. On this field of white, the hose number is also painted. Another white stripe is painted near this, and 78 is indicated, also in paint. In the past, this second stripe was color coded to denote the proper division of the company. Now after a fire, 78 can easily pick up their hose and go home. The engineer is required to keep track of each length of hose on the engine or on the rack, including which numbers are still being used and if they are wet or dry. He records the data in a book kept on the dashboard of the engine for this purpose.

Next to the hose tower door is the stairway to the basement. It contains basic basement contents like the furnace, but this is also where the fire coats, helmets, and boots of the other two off-duty shifts are kept while they aren't working. The coats are lined up hanging from a rod with their corresponding helmets sitting neatly above, all proudly displaying their 78 shields. A double layer of boots is kept on another rack off to the side. On a crude wooden bookcase in the corner are the ambulance journals detailing every Ambulance 6 run. Their counterparts, the engine journals, are kept on a sturdier bookcase at the head of the stairs.

Obviously, the most noticeable feature on the apparatus floor is the massive fire engine. Many makes and models have stood in the same spot on this original concrete floor. The model I remember as a child with the cracked-bench seat and open-air backstep has been replaced with a bucket-seat version with seatbelts for all personnel, complete with an on-board computer. The current model Engine 78 needs to be "plugged in" while silent at the house so that the computer doesn't drain the battery, just as leaving the lights on in your car would drain your car battery. A yellow cord can be seen

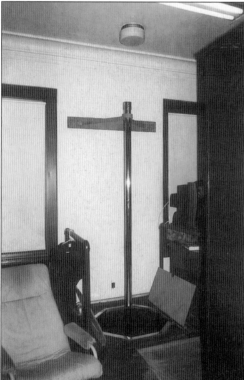

The brass fire pole is still used to get to the apparatus floor quickly. This one is located in the locker room. Notice the close-up image of the pole "hole." Despite popular belief, it is not round.

plugged into the side of the engine. On a run, the power from the engine keeps the computer functioning.

Next to the engine, the ambulance has evolved over the years as well—just as the men and women who now operate her. Gone are the black-roofed, red Cadillacs, replaced with the life-supporting "box on wheels." Through this innovation and sophisticated paramedic training, more lives are being saved. No doubt, modern technology has helped to make the department more and more efficient throughout the years.

Towards the front of the house, two officers' desks are set up on either side of the floor flanking the front door, one for the ambulance and one for the engine. This is where the communications equipment used to receive runs and talk to other fire personnel is kept and all runs for the house are recorded.

Not far from the engine officer's desk is the hallowed brass fire pole. It was invented by a fireman during the horse-drawn era at the turn of the century to speed up the act of getting to the apparatus floor from the second floor where the firemen lived. Now it also gives a firehouse character. A thick rubber pad sits at the bottom to help cushion the landing, but this is deceiving, since sliding the pole improperly can result in serious injury such as broken ankles. From the first floor the pole looks like it dead ends, but this is because the pole hole cover is usually kept closed. Made of quarter-inch plywood, the cover works very much like a storm cellar, with two "doors" on hinges and a handle on each section. When necessary, the handles are grabbed and pulled up and open, the doors being dropped to the side. This gives the men room to slide the pole down to the first floor. They will remain open until much later after the run—when someone remembers to close them again. Engine 78 has two brass poles, one from the

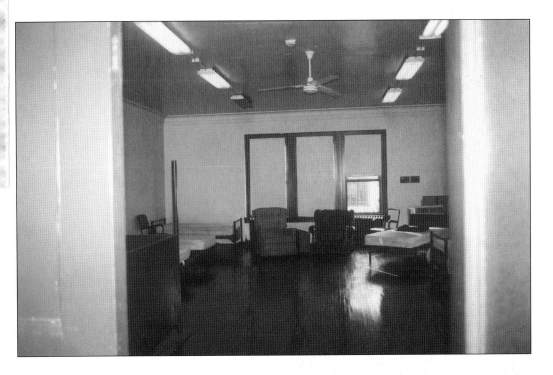

Notice the no-frills conditions of the bunkroom. Built in 1915, it also has a hardwood floor.

bunkroom and the other from the locker area. Rather than continuing through to the roof, the poles come to an end about 6 feet through the second floor, and they are securely anchored into the western wall of the firehouse by sturdy brackets.

The firehouse tour will finish on the second floor. Bathrooms, showers, lockers, and the bunkroom are all located here. The bunkroom is exactly as it sounds. It consists of bunks in a large room with no privacy, just beds lined up one after another. Every morning, each fireman makes up his assigned bunk using his own sheets, then he strips them off again the next morning when the next shift comes in. He keeps them in his locker until his next working day, when the process begins again.

Usually Dad would bring them home during his "Daley" to have them washed, but he would invariably forget them when he went back to work, making it necessary for Mom and I to make an emergency trip to the firehouse to deliver them.

Immediately to the right of the stairway and across the hall from the bunkroom, the massive hose tower continues its journey upward. Inside the tower is a skinny metal ladder used to gain access to the roof. Many of the firehouses built during the early 1900s are very similar to this one, but this house probably has the most spectacular view. Directly out the bunkroom window or from the roof, looking south across Waveland sits the impressive Wrigley Field.

The bunkroom may be plain, but you can't beat the unique view! Beautiful Wrigley Field is just across Waveland, looking out the bunkroom window.

Dad's worn and weathered leather helmet cost him $21.50 in 1956.

CHAPTER 4

IT'S ALL ABOUT PRIDE

George Meyer, engineer of Engine 112, used to tell my dad, "I like to see Engine 78 run with us. Every man is a hero and knows exactly what to do." It was all about pride.

The Chicago Fire Department is a well-oiled machine. Every firehouse in the city has its own basic area, called a "still district." Any fire in this district is known as "your still." Engine 78 is centrally located in the middle of its still district at 3700 North and 1000 West. In the 1950s, 78's still district ran from Buena (4200 N.) to the north to Belmont (3200 N.) to the south, Southport (1400 W.) to the west, to Belmont Harbor at the lake (about 400 W.). Chicago addresses are based on a grid system, with the numbers giving the distance north, south, east, or west from the intersection of State Street and Madison Avenue in the heart of the city. Each 800 numbers, from 3200 to 4000, for example, is 1 mile. A truck company follows an engine on its still, but depending on where the still is located, the truck company varies. Engine 78's trucks generally included Truck 21, Truck 22, or Truck 44.

As the fire escalates and more equipment is needed, it is upgraded to a "box." Companies surrounding your district then join in the fight. The term "to pull a box" means to upgrade the fire from a still to the next higher level (a box), by orders of the officer in charge. When my dad arrived at a place where fire was blowing out the windows, he would immediately request the Fire Alarm Office to give him a box. This triggered more companies to respond.

It is important to point out that there are two kinds of boxes. The first kind we just discussed is an upgrade from a still. The second kind occurs when a "box" is pulled on the street. The Fire Alarm Office (FAO) does not know the exact situation regarding the fire, so as a precaution all box companies are sent when a street box is pulled.

Boxes are usually located on street corners and in front of public buildings, such as museums, movie theaters, hospitals, nursing homes, and schools. The boxes still left in service today can be pulled by the public. In the early days, only a fireman could pull a box. Wherever he went, he carried a brass box key on his key ring. The shaft is round and hollow, and if held to your lips just right, it makes a dandy whistle. I am proud to own my grandfather's. If the fire department was needed while a fireman was around, he would open the box with his key and "pull the box." That is why firemen were allowed free admission with their families to movies, ball games, and other events. If a fire broke out, the owner of the establishment knew that help would arrive more quickly, since the box outside his business was wired directly to the FAO. Remember, the old FI7–1313 phone number was not nearly as quick or accurate as the 911 dispatch system of today.

Often when maintenance was performed on the fire alarm system at a school, a firefighter was requested to stand duty while the system was inoperative. His job was to sit in the doorway of the school, and in case of a fire emergency his sole purpose was to go to the box out in front to send in the alarm. During recess, the firefighter was often invited to take a well-deserved break with the teachers in the school cafeteria while the kids were all safely outside.

In later years, when the public was allowed to pull the alarm, the school fireboxes could be pulled inside the school. This action would trip the box on the street and relay the signal to the FAO. When the box on the street was later opened, a bar 1 1/2-inches long and three-eighths of an inch wide would appear upside down with the word "SET" engraved in it. If the bar could not be righted and it flipped back to the inverse position, it meant that the box was pulled inside the school and it needed to be reset there before it could be reset on the street to make the system operative again.

Before the days of radio communication within the department, the chief in charge or his "buggy" driver at the scene of a fire would go to the nearest firebox to signal information to the Fire Alarm Office. Located

These box keys were used at one time to open fireboxes on the street, before the public was allowed to pull them themselves. Notice the larger hole in the middle key. This one belonged to my grandfather, who went on the job in 1928. The key is more worn than the others, which belong to my dad.

on a slide inside the box is a mini Morse code-type tapper, used to communicate the situation to the FAO. This could either be the escalation of the fire beyond its current status, a request to bring more fire equipment, or to signal that the fire had been struck out and to send any remaining responding companies back home.

Naturally, Engine 78's box district was larger than its still district. It still extended east to the lake, but it also went as far west as Ashland (1600 W.), north to Lawrence (4800 N.), and south to Diversey (2800 N.). The box district added about four blocks around the still area. Box districts overlap to allow more equipment to respond when needed.

It was a matter of pride when the box would come in not to allow another company to beat you, especially if it was your still. This is best illustrated by example. For instance, a box came in at Broadway and Irving Park Road. It is 78's still, but on the box both E78 and E83 to the north will respond. Engine 78 had better get there first, or there would be some good-natured "ribbing." Even better was to beat 83 on a box to their own still location! This is the reason why the engine would be moving almost before the guys were on the rig. Many times Dad would grab the bar over the backstep with only one arm in his fire coat. He often wasn't fully in his gear until they reached Kenmore, a half-block away.

John Burek was the engineer in those days. He smoked awful cigars and had slicked-back gray hair, but he sure could get that engine to move. Runouts were a timed test to see how

quickly a company could get itself together and out the door. An inspector from downtown would show up at 78's door to announce it was time for a runout. All the guys would get up in the bunkroom. When the bell rang, the stopwatch started. All the men had to slide the pole, grab their gear, jump on the engine, and the rig had to cross the house's threshold before time was stopped. Guys would slide the pole one after another, most often while one was at the bottom, one was in the middle, and a third guy was just jumping on. Engine 78 could do a runout in nine to eleven seconds. NOBODY would ever take their fire! Pride was at stake.

In the 1950s and '60s, most of 78's boxes were numbered in the 8,000's, except for special boxes numbered in the 25,000's and 31,000's, such as hospitals and schools. When a box was pulled or a fire upgraded to a box, the box number was sent to all firehouses. The sounder, also known as the Joker Stand, looks like a Morse code telegraph machine housed under a glass cover, including a tapper to send messages and a button on each side—one red (to ring all the bells in the house) and one black (to suppress the bells). Rather than dots and dashes, this system uses a series of numbers to communicate. When the box came in, it was repeated four times, each digit separated by a short silence, thus Box 8112 would come in as eight taps, one tap, one tap, two taps, then this sequence repeated three more times. On the third and fourth time through, every bell in the house would ring automatically, unless the black button was pressed to subdue them. By the same token, pressing the red button would wake up everyone by ringing all the house bells. The man on watch had to be very careful not to wake his coworkers unnecessarily if it wasn't their run, but most firefighters were extremely conscientious and slept with one eye open anyway, often hearing the box come in long before the bells rang. A ticker-

The "Joker Stand," also called the "Sounder," was used to relay run data to the firehouses via a tapping system using numbers. It is no longer in use today.

CHICAGO FIRE DEPARTMENT

Edward J. Kelly
Mayor

Michael J. Corrigan
Fire Commissioner

TELEGRAPH CALLS, SIGNATURES & SIGNALS
EFFECTIVE – FEBRUARY 1, 1945

The Morse Code-like system used by the Chicago Fire Department consisted of a number system, not dots and dashes. Shown here is a copy of the "Telegraph Calls, Signatures & Signals" chart that hung in every firehouse above their sounder. This version is dated February 1, 1945. Edward J. Kelly was Chicago's mayor, and Michael J. Corrigan was the fire commissioner at the time. The complete chart, shown here, indicated signatures for every firehouse and chief in the department, besides codes to report that the fire was struck out or to make a request for other apparatus.

tape-like ribbon of paper with pink dashes spit out of the sounder for every incoming message. That tape could also be checked to see the exact box number.

Laying flat next to the sounder on top of a cabinet was a slate blackboard and a piece of white chalk. The times and locations of all runs were noted here and recorded officially into the journal with details after returning from the run. The cabinet beneath contained three drawers of cards. These "running cards" were organized by box number, gave the box address, and stated instructions as to which company was supposed to respond to the box, as well as who responded and when, as the fire was upgraded to a greater alarm designation. It was the responsibility of the man on watch to know who was out and where so the company could respond

CO. NO.	LOCATION	SIGNA-TURE
71	6255 N. CALIFORNIA A. 3HEldrake 7137.	7-1
72	7982 SOUTH CHICAGO AV SAGinaw 9845.	7-2
73	8630 EMERALD AVE. VINcennes 8820.	7-3
74	10615 EWING AVE. REGent 1285	7-4
75	11958 S. STATE ST. PULlman 3275.	7-5
76	3517 CORTLAND ST. ALBany 0311.	7-6
77	1224 S. KOMENSKY AV ROCKwell 10028.	7-7
78	1052 WAVELAND AV LAKe View 0005.	7-8
79	5858 N. ASHLAND AVE LONgbeach 6440	7-9
80	625 E. 108th ST. PULlman 0164.	8-10
81	10456 HOXIE AVE. South Chicago 0965.	8-1
82	817 E. 91st ST. RADcliff 0001.	8-2
83	1219 GUNNISON ST. LONg beach 8553.	8-3
84	5721 S. HALSTED ST. WENtworth 2343.	8-4
85	3700 W. HURON ST. KEDzie 2108.	8-5

Here is a close-up depicting how Engine 78 was represented. Note the handwritten characters.

quickly if necessary. After he checked these cards, the instructions were written on the slate as a helpful reminder.

The sounder was not used just to signal boxes. It was also used for general communication to and from the firehouse to the Fire Alarm Office. Different series of numbers had different meanings. Some of the more common ones were: 24 to denote a company was Out of Service, 33 was Attention Department, 43 instructed the firehouse to Pick up Talker, and 335 was the code to signal a Return to Quarters. It is interesting to note that at firefighter's funerals, a bell is still used to sound the 335 code to signal a return home. This system allowed the FAO to keep track of their companies, telling them which companies were where, and it was their only way of doing so. The talker was a phone handset with no dial. A second talker was located in the northwest corner of the kitchen so runs could be monitored during mealtimes. When the FAO needed to verbally communicate information to the company, they were signaled to pick up their talker to hear the message. This method was used to signal a still alarm. For example, "7, 8, 7, 8, 4, 3, 2, 1, 2" means Company 78 (twice), 43 (pick up talker), 212 (FAO signature). The man on watch would respond by picking up the talker and listening to the address of the still, and then signaling back by tapping "5, 5, 5, 7, 8," where 555 means Unit to Still Alarm, and 78 is the company's signature. At the same time, the truck companies who would follow Engine 78 were also required to pick up their talker to find out if it was their still and if they were supposed to follow. Let's say Truck 44 was supposed to follow in this example. The man on watch at 44's house would tap out "5, 5, 5, 3, 5, 4." Again, 555 means that they are also responding to the still alarm, and 354 is their signature. All truck company signatures are three digits and begin with a 3, then 1 is subtracted from the second digit, thus 354 is T44's signature, 331 is T21's, and 332 is T22's. A man had to be on the ball while on watch. No speaker opened up giving the location of

the fire. It was simply a matter of paying attention and knowing the sounder.

At one time, all firehouses in the city had a chart hanging over their sounder detailing signatures and signal codes. The meticulously handwritten "Telegraph Calls, Signatures & Signals" also listed every company location with their addresses and phone numbers, all division marshals and battalion chiefs, the Fire Alarm Office, and all special units such as the Insurance Patrols, department mechanics, and gas trucks.

This code system is the same one mentioned earlier in regards to the chief or his driver signaling the FAO from the fire scene using the tapper located inside the firebox. This system of communication was used exclusively throughout the Chicago Fire Department long before radios and computers became the standard.

Another special piece of equipment is the Marshall Line. This red phone is similar to a department extension system used in most businesses. Four digits are dialed to call anyone from the FAO, to the repair shops, or to another firehouse. Engine 78's Marshall Line number is 9278. The Marshall Line can only make and receive calls from inside the department, and it is not hooked up to the outside world.

So far we have learned about stills and boxes, but as a fire intensifies, more equipment is needed, and the designation of the fire changes, signaling which companies are to respond. Each level of the blaze brings with it more equipment from a larger surrounding area. A fire starts as a still, then progresses to a box, then becomes a 2–11, 3–11, 4–11, and 5–11 as it intensifies. If the fire escalates past a 5–11, Specials are called, such as a "5–11 with 1 Special." The largest fire on record is a 5–11 with 14 Specials when the Union Stockyards burned in 1934. This far south-side fire was so large that companies on the north side of the city were called to help. My grandfather on T44 fought the fire for two days, causing him to miss his sister-in-law's funeral. The Our Lady of Angels School Fire

we talked about earlier was designated a 5–11 immediately, ignoring department protocol to call as many pieces of equipment on the scene as quickly as possible.

While a fire is raging and firemen and equipment are being brought to the scene, gaps in coverage are created in other areas of the city. To help alleviate this condition, other companies not involved with that particular fire may be sent to cover another area. The procedure is called "changing quarters" and is implemented starting with a 2–11. Change of quarters instructions were also listed on the running cards discussed earlier. A card may state that on a particular box E78 changes quarters on the 3–11, but responds on the 4–11. For instance, if there is a warehouse fire in the loop, south and east of 78's quarters, and the fire escalates to a 3–11, then Engine 78 is instructed to change quarters to Engine 55's house, on Halsted to the south of them. E78 picks up their gear and hightails it over there, assuming 55's runs and perhaps some of their own, as directed by the Fire Alarm Office. Engine 78's men will generally stay at 55's house until E55 returns home, unless 78 is sent out on a run of their own. Depending on the fire situation, 78 may return to their own quarters, or they may return to 55's house as directed by the Fire Alarm Office. When 55 does finally return home, 78's guys will usually help 55's gang with their wet hose before they go back to their home. If the change of quarters occurs at night, the visiting company might want to try to get some sleep. It is considered rude to sleep on another man's sheets, so an extra blanket is placed over the other man's bunk, then the visiting firefighter lays on top of it removing only his shoes since he didn't bring his bunkers, and he uses another blanket on top. He may actually get a bit of sleep this way.

The longest change of quarters Engine 78 ever had was to Engine 29's house at 3509 South Lowe, down the street from Comiskey Park. This change was due to a 5–11 with 7 Specials, again at the Union Stockyards. It was a long trip, literally from one ballpark to

CODE	
O.K.	2
REPEAT	3
CALL F.A.OFFICE ON PUBLIC PHONE	4
RETURN TO QUARTERS	5
SEND...ENGINES TO FIRE.	10
PUT GROUND PLUG IN JOKER LINE	1-2
TAKE GROUND PLUG OUT OF JOKER LINE	1-3
NOT HERE	1-4
SEND FIRE BOAT TO FIRE	1-5
SEND.... FIRE INSURANCE PATROLS TO FIRE.	1-8
SEND DIVISION CHIEF TO FIRE	2-1
SEND CHIEF OF BATTALION TO FIRE	2-2
SEND WINCH TO FIRE	2-3
APPARATUS OUT OF SERVICE	2·4
SEND CHEMICAL UNIT TO FIRE	2-5
SEND HIGH PRESSURE WAGON TO FIRE.	2-6
SEND WATER TOWER TO FIRE	2-7

The close-up view shows some of the signals used. Notice that the fire patrols were still in use. The code 1–8 was a request to send them to the scene.

another.

This is a good point to indicate that riding the backstep was not as easy as it looked. The eyes took a beating from the wind riding on the back, and they especially needed to be protected in cold weather. My dad used to tuck his helmeted head partially under the canvas cover of the hose bed to shield himself from the biting wind. He said many times after riding on the backstep that his eyes felt as if they would fall out of his head.

Engine 78's backstep is rich in folklore. On the right side of the backstep area was a buzzer. If the boys needed the engine to stop, this is what they used to signal the engineer. Motorists continually follow the engine too closely, and it can be a problem. Short of stopping the engine, another way the boys used to deter tailgaters was to toss a handful of gravel on the street directly behind the engine. Once the gravel jumped up under their car making noise, the drivers would usually back off. A small can of it was always kept within easy reach just for this purpose.

Probably the most unusual piece of backstep "equipment" that 78's crew once carried was a cigar box. On the way to a run, any firefighters with dentures stowed them safely in this box until the fire was struck out, since fighting a fire with gagging smoke will often cause a firefighter to vomit. If this happened to a firefighter with false teeth, they would come out and just be a mess. Keeping the cigar box in a compartment on the backstep helped to alleviate this problem. Unfortunately, the box was no longer in use on January 18, 1958, when six two-and-a-half-story frame buildings at 3025–31 Sheffield caught fire. Since the houses formed a square around a backyard area, the guys placed themselves in the middle, back-to-back, working the lines. Dad was working a 3-inch line with an inch-and-a-quarter shut-off when he hit Jimmy Barrett in the middle of his back with the powerful stream of water. Out popped his dentures. After all the fires were out, the 78 gang sifted through the rubble and ashes with sticks looking for this man's false teeth. Perhaps they should have kept the cigar box idea around a little longer.

All engines also carry a hand pump on their rig. This is best described as an industrial sized fire extinguisher and is used for fires where "leading out" (stringing hose to a hydrant) is not necessary. Hand pumps are used to extinguish approximately 75 percent of fires. In 1956, 18,926 fires were struck out citywide using only a hand pump, compared to 6,967 fires extinguished leading out from an engine with one or more hose lines. It was the officer's responsibility every morning to lay his hand on the top of the pump and hope that his fingers touched water inside. If it didn't, it wasn't full, and

instructions would ring out to fill it up. A fully filled hand pump weighs in excess of 50 pounds, contains 5 gallons of water, and is usually the candidate's responsibility to operate.

Chemical extinguishers are used on small electrical fires because water is far too dangerous. The electrical current can quickly shoot up a direct stream of water and electrocute the firefighter. If the fire is too big and a hose line is used, it must be left on a fog setting while using a circular hand motion to apply the water to douse the flames. Even though chemical extinguishers are very effective, they can be extremely hazardous due to the choking powder released when they are being used.

Commonly known as the "Jaws of Life," the Hurst Tool is not carried on an engine. This is the tool that can open car doors like a can opener and is quite useful in rescue operations, so it makes sense that they are carried by truck and squad companies.

Engine 78 is a good house for a candidate to be assigned. Here he will learn about all kinds of fires and conditions. Especially in the 1950s and '60s, 78's gang took care of it all, including high rises, transient hotels—then called flop houses (most of them now gone)—apartments, warehouses, houses with multiple stories, buildings with peaked and flat roofs, and a variety of industries. This is where a candidate learns to respect fire and its awesome power.

At one time, Engine 78 protected everyone from the dregs of society to the social elite. The intersection of Broadway and Wilson was once the "VD Capital of the World," and that location was also 78's box. They protected parts of Marine Drive, the Outer Drive, and Lake Shore Drive, along with coal yards, bowling alleys, and ballrooms. Engine 78 had its share of diversity.

Fire hydrants are taken for granted by most of us, but they do have a unique feature. Every other kind of faucet allows water to flow when turned to the left and to stop when turned to the right, hence the phrase "righty-tighty, lefty-loosey." This is not so with a fire hydrant. Using a special hydrant wrench, it is opened with 13 1/2 turns to the right.

The hydrant is where the soft suction is connected to the fire engine to fight the fire. Chicago's department utilizes what is called a "reverse lead-out." We drop hose at the fire scene and head to the hydrant with the engine, hooking it up to send the water. By the time the water is sent, the situation at the fire building has been accessed, and action is ready to be taken—all in a matter of seconds.

Engine 78 has had her share of unique fires and other emergency situations, but there is a lighter side as well. Besides fighting fires, many firemen are known for their ability to cook and to play practical jokes. My dad was Engine 78's cook for 14 years. His proudest moment came when he was chosen to cook for 21 guys during the '67 snowstorm.

Firemen pride themselves on their cook. No good cook was ever sent on a "detail." A detail is when a guy is picked from the house for that particular shift to work out of another house for the day. For example, Engine 55 might be down two guys due to a furlough (vacation) and a Daley happening simultaneously. The Battalion Chief orders E78 to detail a man to E55 for the day. The assigned man would report directly to 55 the next working day and would not show up at 78 at all. Sometimes the details were voluntary, and sometimes they were assigned. Either way, someone would go, and it usually wasn't the cook.

Every firehouse has "the club." The cook buys the food for the day and charges each man in the club for his share. Dad used to go shopping on his "off" (non-working day) to pick up the next day's food, although this is uncommon. In the 1950s and '60s, the charge per man per day for two good, hearty meals was $1.55. Today it runs in the neighborhood of $10 to $12.

No book mentioning firehouse cooking would be complete without a recipe or two, so here is a typical Engine 78 meal from 30-plus years ago. It still tastes just as good today.

SWEET/SOUR BEANS

2 cans French-style beans, drained
1/2 lb. bacon, cut in 1/2-inch pieces
2/3 cup sugar
1/3 cup vinegar

Put drained beans in a pot. In a frying pan, fry the bacon, then remove cooked bacon with a slotted spoon and set aside. Add sugar and vinegar to the frying pan and bring to a boil. Add bacon and vinegar mixture to the beans, heat and serve.

Variation: Engine 78's version for seven men included 6 cans of beans, 1 lb. of bacon, 2 cups of sugar, and 1 cup of vinegar.

It is interesting to note that on the working day after an especially good meal, other cooks from neighboring firehouses would call wanting Dad's recipes! The recipe for these beans was an extremely popular request. . . it was all about pride.

Now for dessert. The following recipe was perfected by my grandmother, and both my mom and I have won recipe contests with it in local newspapers.

CHERRY COFFEECAKE

2 cups flour
1 stick margarine, softened
1 cup sugar
2 t. baking powder
Milk
Can cherry pie filling
1 egg

Place the egg in measuring cup, then add enough milk to make one cup. Mix dry ingredients with softened margarine, then mix all with egg and milk mixture. Pour into 9-by-13-inch baking pan. On top of batter, pour can of cherry pie filling. For topping, mix 1 cup flour, 1 cup sugar, and 1 stick margarine until crumbly. Spread crumbs over top of cherries and bake 40 minutes at 350 degrees. Good served warm or cold.

Traditionally, meals like this would be served daily in Chicago firehouses, except on major holidays. On days like Thanksgiving, Christmas, and Easter, the local hospitals were happy to provide full meals to their fellow civil servants. A meal of turkey, ham, gravy, sweet potatoes, mashed potatoes, cranberry sauce, and several pies were generously given to most firehouses during this time. All the guys had to do was pick it up. Today, even holiday meals are generally prepared at the firehouse.

POT ROAST

3 to 4 lb. pot roast
One envelope dry onion soup mix
One can condensed mushroom soup
Salt and Pepper

In a roasting pan, place a sheet of aluminum foil large enough to line the bottom of the pan and fold over the meat and seasonings. Place the pot roast in the center of the foil, then salt and pepper. Cover with the onion soup mix and mushroom soup. Fold the foil, sealing around meat and the soups. Bake at 425 degrees for about two hours. Make gravy out of the soups and juices and serve with mashed potatoes.

Besides cooking, firemen have other household duties. Saturdays were scrub-out days, where everything in the firehouse was cleaned and scrubbed. The cook was expected to help, so he often made a boiled dinner since this was easy to prepare by throwing everything into a pot to boil while the housework was being done. Boiled dinners usually consisted of either corned beef and cabbage, smoked butt and cabbage, or spare ribs and sauerkraut.

During scrub-out days, the cabinets were washed, the concrete floor got hosed down, and the brass was polished until it shined. Besides the obvious brass like the fire poles, 78 has other brass fixtures, including the knobs on the running card cabinet, the light switch plates, and the sewer grates on the apparatus floor. It was often Dad's job to make these brass pieces sparkle. He would finish and be taking a well-deserved break in the kitchen, when in would walk Battalion Chief Adolf Peterson. He chewed tobacco and would invariably spit at the sewer, splattering tobacco juice on the newly shined plate. After he left, Lieutenant Marshall simply yelled one word, "Bobby!" Dad would begin cleaning the brass grate until it shined once again.

Besides paying into the cooking club, every guy at 78 paid $1 per month for house dues. A house treasurer was elected to hold the money and dole out the funds as

necessary. This paid for things like a new refrigerator or necessary TV repairs. Revenue received from the pay phone and pop machine in the house also went into this fund. Daily newspapers for the house were usually dropped off by the *Tribune* and *Sun-Times* delivery men as a free courtesy.

Firemen can be extremely helpful to each other, but they also like to play. When a candidate reported for work, the cook would take him aside and ask the poor lad if there was anything he did not like to eat. If the boy answered honestly, he was doomed. The offending meal would be served for the next three months of shifts.

The first thing the guys wanted to determine was if the candidate had a weak stomach. This joke was played on my dad. After corn-on-the-cob for dinner, while still sitting at the kitchen table, Swede Nelson casually dropped his false teeth into his great, big, handleless coffee cup filled with coffee. Pieces of corn floated to the top and Swede nonchalantly sucked them off.

Sometimes the joke was more mental than physical. Ambulance 6 got a run, and Dad decided that a joke was in order. He mixed gingersnap cookies (beige-brown in color) with the proper amount of water to form a concoction resembling something better left in the bathroom. He dropped slugs of this offending mess onto the toilet seat of the first-floor bathroom, right off the kitchen. Imagine what that must have looked like. The engine got a run, and Dad left. A few minutes later, the ambulance returned as one of the neighborhood guys was seen coming out of the toilet. Harry New York knew the joke and walked out of the bathroom when he realized what was going on, but Rich Lambrecht of the ambulance simply caught him walking out, thinking he had just used the facilities. Rich wandered in to find the disgusting mess. It was at that moment that the engine was backing in after its run. Lambrecht excitedly ran over to Dad exclaiming, "Bob, come look at what that Harry New York did!" Dad willingly followed

him into the john, then calmly stuck his finger into the goo, picking up a chunk of the mess. In spellbound disbelief, Lambrecht watched as Dad placed the sample on his tongue and expertly proclaimed, "Sure tastes like s**t!" Lambrecht was gagging in seconds.

Another good candidate joke was the "Short Bunkers" routine. Gus Aparo came as a candidate to Engine 78 eager, as they all are, to be a fireman. One of the most exciting parts of firefighting was getting up in the middle of the night and hustling into your bunkers, down the pole, and onto the engine when the alarm sounded. After Aparo was asleep, the boys exchanged his normal bunking pants with a "special" pair. The pants were draped around his boots as usual, but the pant legs had been cut off to short length. Around 11 p.m., Capt. Gibbons rang the bell and as anticipated, Aparo excitedly jumped up for the run, threw on his bunkers, and was shocked to find his legs hanging out of his pants but knew he had to be on that engine no matter what. His legs squealing as he slid the pole, he jumped on the engine only to feel the captain's mighty paw pull him off. The captain sternly warned Aparo, "You're not going to disgrace this house going to a run looking like that!" A bewildered Gus realized that the joke was on him when he noticed the guys snickering around him.

Jokes were not just for candidates—officers were fair game, too. Dad acquired a page of peel-off caps (for toy guns) he refers to as "horse caps." All the bunks in the bunkroom are on rolling casters. Dad managed to remove the casters from Captain Gibbons' bed undetected to pull off this joke. The legs of the beds are slightly concave at the bottom since this is where the casters attach. A horse cap was placed between two pennies with their heads facing each other to give it the proper thickness. This stack fit unnoticed under one leg at the head of the bed. A similar pile was placed under the opposite leg at the foot of the bed.

Any weight on the bed would cause the caps to pop, scaring the captain. Gibbons went to bed, and within seconds the first cap let go. It sounded just like a firecracker, and he jumped but eventually settled down and slept through the night. The next morning, the other cap let loose as he shifted his weight just right. From the bunkroom he yelled, "Kruse, I don't know how you did it, but I KNOW it was you!" Dad went back later, retrieved his four pennies, and replaced the casters. The captain never knew what had happened or how.

Firemen can be fun guys, but when they are working it's best to stay out of their way and let them do their jobs. That pertains to your car, too. More than once, a car parked in front of a fireplug has had a soft-suction hose put through it, hooking the engine to the hydrant in the urgent rush to put out a fire. There is no time for jokes when lives are at stake and time is of the essence.

They love to cook and they love to play, but they are always firemen first. It is all about pride.

The men of Engine 78 and Ambulance 6 are pictured here outside their quarters on March 15, 1956. They are, from left to right: (front row) Mel Roloff and Dad; (standing) John Burek, Frank Chambers, Lt. Marshall, Joe Templeton, and Pete Castony. Their dog, Pat, can barely be seen directly in the front. Dad was on the job almost a month when this photo was taken.

CHAPTER 5

LEATHER LUNGS AND
BRASS FITTINGS

Dad reported to Engine 78 on February 18, 1956, as a candidate raring to go. He went home the next morning sorely disappointed, as she never moved a wheel during his shift. The next working day, February 21, proved to be a bit different.

The engine sitting silent all day, Dad commented to the engineer around 9 p.m. how 78 must be a "crow outfit," meaning they didn't get any action. The engineer swore loudly, and after calling him several choice names, prophesied they would probably be going out shortly. About 10:30, the call came to respond to the three-story corporate headquarters of Curtis Candy, located at 1101 West Belmont, at the southwest corner of Seminary.

Upon arriving on the scene, the 78 boys went to work, first trying to fight the fire by working the line inside the building. Mel Rollof and Joe Templeton were on the pipe (hose). The fire was already in the walls and ceiling by this time. Battalion Chief Adolph Peterson acknowledged Dad, asking how he was doing. Chief Peterson had been my grandfather's captain at Truck 44 and recognized my father.

Before long, the gang backed out of the fire and were ordered to set up a "point of vantage" on the roof of the building to the west. This would allow them to fight the fire from a better position on the outside. A "Bangor" ladder was used to gain access to the roof of the building next door. A Bangor ladder is an extremely rugged, reliable extension ladder, with two poles called "tormentors" permanently attached on either side. These raise and stabilize the ladder, then fold flush when not in use. Invented just after the Civil War in Bangor, Maine, this ladder's design proved more durable than many of the first extension ladders. A 50-foot Bangor ladder weighs 550 pounds, requires six men to raise it, and can extend up to five stories. It easily reached the roof of the neighboring three-story structure.

Without hesitation, Lt. Marshall hollered,

"Bobby! You're just out of Drill School, get up there and tie a chimney hitch." Dad did as he was told, scampering up the ladder with a coil of three-quarter-inch rope and a "hose roller" on his back. A hose roller is an "L"-shaped metal piece about a foot wide, made to fit over the top edge of a building. Spaced along the hose roller are wooden spindles, enabling the hose to easily roll up and over the edge of the building.

A chimney hitch was made with the rope, and the 3-inch hose was pulled to the roof over the hose roller, then a wall hook was used to take pressure off the heavy line hooking it over the edge of the roof. A loop of rope was also used to secure the hose hanging over the side of the building preventing it from sliding back into the street.

The fire raged to a 4–11 blaze in the bitter 12-degree temperature. It didn't take long before Dad felt his neck go weak, and it became a struggle to hold his head level. It was then that he realized his whole helmet had become encrusted with a thick layer of ice. Once this was discovered, he cracked it on the roof coping releasing the extra weight.

At 8:30 the next morning, E78 was finally relieved to go home. By that time, Dad understood the true legend of Engine "78"; they are called 78 because their fires often start at 7:00 p.m. and continue until 8:00 the next morning. Back safely at the firehouse, Dad rescued the pink-dashed ticker tape output from the Joker Stand's wastebasket, acknowledging his first run and the beginning of his memorable fire department career scrapbook. The morning's paper carried pictures of the impressive blaze with its ice-covered equipment. Many of his runs would be catalogued in this scrapbook by newspaper clippings over the years, this was just the first of many. Engine 78 was no crow outfit.

Later that same year, on November 6, 1956, at 5:36 p.m., during the height of rush hour, a CTA "L" train rammed the rear of a North Shore Line express train standing in the station at Wilson and Broadway. Engine 78

Fire Puts 'Icing' on Candy Plant

Engine 78 responded to a number of hazardous duty calls in 1956. This 4–11 blaze at the corporate headquarters of Curtis Candy was fought February 21, 1956, in frigid temperatures. This was Dad's first run. The call came in at 10:30 p.m., and they were finally relieved at 8:30 the next morning. (**Chicago American.**)

was sent on the box to this "special duty" run.

When they arrived on the scene, they found a flight of stairs up to the tracks. There, one train literally rested on top of the other. The floor of the top train had squeezed up and crushed the legs of passengers trying to get home after a long day at work. The sides of the train were also wrinkled due to the force of the crash. The victims would have to be cut out individually.

One man had his right shoulder and leg pinned behind a door beam, as his left side hung out the train's doorway. The firemen needed to cut the beam with an acetylene torch, then bend it back to free him. The

Hurst Tool, commonly known as the "Jaws of Life," was no help since it was not invented until 1972.

To protect the victim from hot sparks and melting steel, a blanket was placed over the top of him and soaked. As a candidate, Dad was still on the hand pump, and it was his job to keep this poor man wet and protected. Every once in a while, white-hot molten metal would drip through to the trapped victim, burning his flesh. He would let out a blood-curdling scream, causing Dad to pump harder. When he ran out of water, another firefighter stepped in with another hand pump to keep the process going while Dad

refilled his pump. At one point, a newspaperman wanting gruesome pictures for his evening paper refused to get out of the way. A hand pump was dropped on his instep, thereby solving the problem. Finally, after much effort, a block and tackle was rigged up and the trapped victim freed.

There were many scenes of suffering throughout the train. A doctor on the scene, helping where he could, needed someone to hold a flashlight while he sewed a man's eye shut. Hopefully, this move would save the eye and at least stop the bleeding. A policeman held the flashlight for a while, then bailed out as Dad took over. When they found the motorman, his leg was sliced from his groin to his ankle, and he was removed dead. In all, seven people died, and many more were seriously injured.

After witnessing such great carnage and loss of blood, they returned to the firehouse to find their ice-cold dinner was still waiting for them—Swiss steak with cranberry sauce. In a gruesome way, it reminded more than one man of the previous run. In this house, a guy learned to eat whatever was placed before him, whenever it was placed there.

Many people die in fires and accidents yearly, and firefighting is not called the most dangerous profession for nothing. On Christmas Day in 1957, a fire broke out in a liquor store on the northwest corner of Belmont and Clark. This building at 842–848 Belmont and 3208–3210 Clark was originally a three-story structure, containing a cigar store, tavern, and liquor store. There were three store fronts on each street side. The top two floors burned off sometime in the 1920s, then a roof was put on directly over the remaining flooring of the second level.

It was at this fire that Chief Russell Grundy lost the tip of his nose while pulling down the tin ceiling looking for hidden fire. A sheet of tin sailed through the air, slicing off a piece of the chief's nose like a hot knife through butter. The papers the next morning showed a picture of him lying in his hospital bed with his nose bandaged.

At the same fire, the roof caved in while some of 78's gang were standing on top of it, fighting the fire from above. Suddenly my dad fell through space, but luckily he stopped short after falling only a couple feet. He had landed on top of an upright freezer, preventing what could have been a dangerous fall. The hazards of fighting fires are many.

The boys were in for another rough one when they took on the Lake View Bowling Alley on January 28, 1961. That same morning, nine firemen were killed when a wall collapsed on them during a fire at 614 Hubbard Street. Engine 78's bunch were watching the TV coverage around 12:20 in the afternoon, when the run came in to respond to 3239 North Clark Street, the Lake View Bowling Alley. As they ran out the door, Dad told Jimmy Stewart of the ambulance team, "Watch the TV, you're going to see us." No truer words were ever spoken.

The bowling alley was a three-floor structure with 18 lanes on the second and third floors, and 50 lanes in all. Dad was on the pipe with Captain Danny Jones. They made their way to the third floor and through the swinging, wooden doors. The captain moved ahead, throwing barstools over the horseshoe-shaped bar to get them out of the way. The public often doesn't realize that fires are extremely dark, and it's easy to trip over unknown debris.

Fire was showing in the southeast corner of the floor. Captain Jones told Dad to hit that first when he got his water. The only problem was that the hydrant directly out front was frozen, so the water was not coming. Engineer Burek had already determined this and was on his way to Belmont to try the hydrant there. By that time it was too late. What the guys did not know was that the fire was already in the walls, ceiling, and floor all around them. The previously visible fire suddenly went out and was replaced by an eerie silence, and then started to rumble and hiss. . . it was a backdraft. Jones yelled, "Run!"

The Wilson Avenue "L" crash happened at rush hour on November 6, 1956. Here, a fireman keeps a trapped victim wet and protected from the torch used to eventually free him. My dad is on the right side of the picture (with the small "X" over his head), waiting with the next handpump filled with water to take his turn trying to protect the injured man. This caption reads, "screams of 'I'm burning, I'm burning' rang out from the wreckage." (**Chicago American**.)

As it blew, Captain Jones started rolling sideways down the stairs with Dad in hot pursuit trying to catch him. He finally caught up only because Jones stopped rolling on the landing between the second and third floors. Complaining of back pain, Dad carried him out, and off to the hospital he went, but not before making Dad the officer in charge. It was the first time my dad had this responsibility.

Undaunted, Dad grabbed Jim Haffey, and they ran back in to rescue their abandoned line. Dad aggressively ordered them to get in there and hit that fire. Our uncle, LeRoy Wise from Engine 112, was overhead proudly saying, "That a boy. That's my nephew." Haffey got knocked out and had to be carried out before he, too, went off to the hospital.

By this time the building was a loss, and all that could be done was to pour water on it until the fire was out. They shut down their lines and came outside to hook them into a squad and used their turret gun atop. Squads are special duty units and were the only ones to carry a turret gun at that time. A turret gun is a high-powered nozzle set on top of the apparatus and can shoot water great distances. Currently, almost all engines have turret guns of their own.

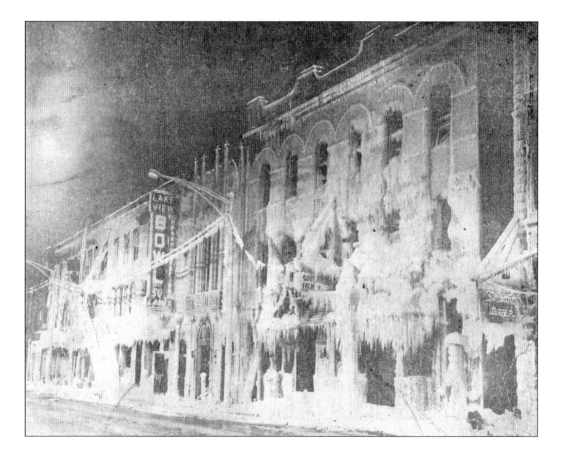

The Lake View Bowling Alley met its end on January 28, 1961. When this "backdraft" blew, 78's guys were blown down the front stairs. This fire burned all through the very cold night, firemen not being relieved from duty until the next morning. Notice the fascinating sculptures formed by the ice. (Source unknown.)

Around midnight, Burek called Dad over to the engine. "Get inside," he whispered. There in a bag were ten warm corned-beef sandwiches, complete with dill pickles, which a civilian had so kindly dropped off. Dinner never tasted so good. At 8:30 the following morning, 20 hours after the run had come in, 78 was finally relieved to go home.

The official Chicago Fire Department photographs dramatically show the massive amounts of ice created while fighting this fire, turning the rubble into an ice sculpture. Neighboring businesses were affected, and cars left in the area were frozen in huge blocks of ice for days.

Bowling alleys are notorious for the fumes they produce, due to toxins created by the oils used on the lanes. Masks were not worn until the late 1970s, and even then were not mandatory until much later. The only companies to carry masks in the 1950s and '60s were squads, and they were generally called in for something like an ammonia fire. Keep in mind that all these fires illustrating 78's runs were fought without masks. The phrase "leather lungs and brass fittings" means that is what you needed to be a firefighter—"leather lungs" to handle the smoke and "brass fittings" to be brave enough to go in and do the job.

Sometimes smoke got the best of them anyway, like at the Bowlium Bowling Alley fire at 4361 Sheridan Road on February 27, 1959. The fire was located in the sub-basement of the place where cases of paper matches were going up in flames. My dad got in and took care of the fire, but it was evident that the sulfur from the matches was taking its toll. Other firefighters relieved him of the line, and minutes later caught him as he was sliding down a wall about to pass out. They got him outside, but instead of sitting on the curb with the nine other firemen also overcome by smoke, he insisted on standing. Burek ran into a nearby tavern and retrieved a barstool. Naturally, the papers the next day showed him taking his oxygen while propped up against the barstool. The guys may have gotten knocked out, but E78 was proud to have beaten E83 to their still and taking their fire.

Quite often the problem with a fire is not its smoke but its heat. This was the case at two such fires. On November 26, 1962, 40 ice cream trucks all caught fire at the Mr. Softie Ice Cream Co. at 3301 North Halsted. This 4–11 was so hot, three hundred residents were evacuated from neighboring homes by firefighters. The 5–11 at the Arcadia Garden Roller Rink at 4444 Broadway on January 4, 1959, was so intense that the tarps of a squad company caught on fire. When 78 arrived on the scene, the roller rink was fully involved. There were no windows in the structure except one about 12-by-18 inches, located high up on the peak of the building. Engine 78 hooked its lines into the squad and used its turret gun to direct water into that window. The roof caved in, sending a rolling wall of fire into the street, engulfing the squad and setting the tarps on fire. Dad directed the turret gun straight up in an attempt to extinguish themselves while he and Gus Aparo tried to further smother the fire with their hands. Being January in Chicago, the nearby cars were encased in ice for quite a while after this fire.

January doesn't bring just fires to Chicago, but also snow—lots of it. On January 26, 1967, it started snowing. Four inches of snow was originally predicted, but by the time it stopped late the next morning, Chicago had 23 inches of the white stuff. At 2 a.m. Friday, January 27, Dad got the call that all leaves were canceled, and all firemen were expected to report to work as soon as possible.

My dad tried to leave the house as quickly as he could after getting the call, but the car got stuck in the snow at the bottom of the driveway and was not going anywhere. He would have to take the train, but the first one didn't run until 5:30 a.m., so he came back inside, had a good breakfast, and tried to sleep a couple more hours before trudging

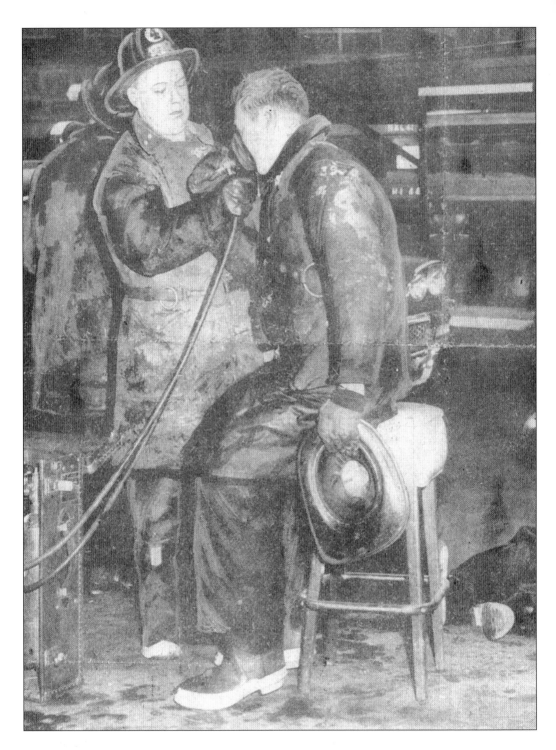

The Bowlium fire on February 27, 1959, caused 10 firemen to be knocked out, including Dad. In fact, that's him on the barstool receiving oxygen. Sulfur from burning matches was blamed for the intensity of this blaze. **(Chicago Daily News.)**

to the train station a few blocks away at Northwest Hwy. On his walk to the train, Dad heard a moan. At first, he had no idea where the sound was coming from, but he soon realized that a man had fallen in the ditch beside the road in the heavy snow and was calling for help. Dad helped him out and over to the train station, where he could catch his breath and warm up. This snow was extremely deep and treacherous.

Dad was able to get on the first train and headed southeast to approximately Irving Park Road and Pulaski. The streets were plowed, but getting around was still a challenge. He managed to bum a ride to Clark Street, where he caught a bus going south to Waveland. From there he walked the block to the firehouse. As he approached, E78 was just backing in from a 3 or 4–11 run up north, where terrified people were jumping out of windows. This was just the beginning of five very long days. The 8:00 bell rang moments after Dad walked into the house. When he had the chance, my dad called my mom and ordered her to keep me inside. After the incident with the man in the ditch earlier, he realized that the snow was far too deep and dangerous, especially for an eight-year-old girl.

When everyone arrived, there were 21 men, seven from each shift, living in the firehouse. The place was crowded, but they would manage. The first order of business was to determine who would cook. It was Dad's finest hour, as he was unanimously elected to fill this role. In the days to come, he would have soup on every morning at 7 a.m., such as bean with ham, or beef vegetable, and then served hearty meals throughout the day.

At first, everyone did everything. All the guys went out to clear fire hydrants, fight fires, and move cars, but with only seven beds in the house, this became difficult as guys were sleeping on benches, on the engine, or on the pool table in the basement when they all tried to sleep at once. Captain Gibbons provided the necessary leadership and took control, separating the guys back to their original three shifts. One platoon would spend eight hours on the street digging out hydrants and moving cars to clear the streets as much as possible. Approximately 50,000 cars had been abandoned in the city. To help clear the way, the cars were bounced up and down by the men in order to physically move them to the side of the road. The second platoon would clean the firehouse, do dishes, and take runs on the engine while the third platoon slept. After eight hours, everyone rotated. The wise captain also gave a few "garbage" orders, making the men angry at him but not each other. This was important for morale as they banded together to work as a team. Many of the other firehouses had brutal fights among the men, in some cases even using butcher knives. Tempers were hot, but 78 did not have that problem—they had leadership.

As hard as they worked, the streets still were not clear enough for the ambulance to take runs. The engine would have to navigate the snow-drifted streets on accident calls, but even they had problems. On one particular run on Wilton, the engine could only get as close as Addison, approximately three-quarters of a block away. The boys walked in to find that a woman had cut her arm badly with a kitchen knife and needed hospital attention. After bandaging her the best they could, Dad was elected to carry the heavy woman back through the 2-foot-high snow to the engine waiting at the end of the block. Exhausted, he settled into the cab of the engine, while the captain hoisted her onto his lap in order to transport her to the old American Hospital on Irving Park Road.

After five days, with the city almost back to normal, the first shift was allowed to go home. Dad arrived home to a very happy, but tearful, reunion.

Another "special duty" assignment of several days came during the King Riots of 1968. Dr. Martin Luther King Jr. was assassinated on April 4 of that year, and within 24 hours, burning and looting started

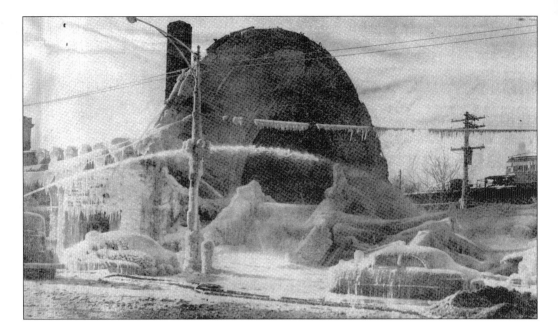

When the Arcadia Roller Rink blew on January 4, 1959, a wall of fire rolled out onto the street, engulfing the squad unit that 78 had hooked into and setting the tarps on fire. Dad and Gus Aparo shot the turret gun straight up, trying to put themselves and the squad out. **(Chicago American.)**

along Madison Street on the city's west side.

My dad was sitting at home when the news began reporting King's violent death and the subsequent riots around the country. He sadly prophesied, "I'll be going." This was the turbulent '60s, and rioting was happening everywhere. Within hours, he got word that all leaves were canceled, and all firemen were expected to report to work immediately.

A curfew was set at 7 p.m., and the sale of firearms, ammunition, and gasoline was banned until the siege was over, but this didn't hinder the looters. In all, 11,000 police, 7,000 Illinois National Guard troops, 5,000 Federal troops, and 5,000 firefighters were involved. A 12-square-mile area was being burned and looted. Troops and firefighters alike were heavily armed.

Engine 78's gang took a bus to the burning Madison Street, but the bus driver would not approach any further, so he dropped them several blocks from the site. They walked the rest of the way into the burning area. There, fire engines with hoses attached to each were strung out along Madison Street. They picked up a hose and fought the fire until they ran out of either hose or fire, at which time they would drop that hose, move westward, and pick up another coming from the next engine in line continuing the fight. Looters were running under the hoses with everything from cigarette machines to dime-store mannequins. Engine 78's guys worked from 2200 west to 3200 west before it was all over.

At one point, Dad was crawling through a burning building, hitting the rolling fire above his head with his line, when he bumped a coffee table. A Princess telephone with a lighted dial fell off the table and landed in front of him on the floor. To his shock, he heard a dial tone. He had already been away from home for a couple days, and

we had heard nothing from him during that time. While lying on his belly and still directing his line at the fire, he called home to let us know he was all right. He was surprised to hear from my mom that it was past midnight, but he told her not to worry. He happened to be in a burning building on Madison Street, but he was fine. I don't think she slept a wink for the rest of the night.

After three days, the fires were out, the looting had stopped, and a sense of order prevailed once more. Again, Dad arrived home to a very happy household. During the siege, 350 people had been arrested for looting, and 162 buildings were destroyed by arson. These ruins were later bulldozed, remaining vacant lots for the next 30 years.

Sometimes special duties start like a normal run. A gas explosion occurred in a house at 3523 North Fremont on January 18, 1967, 78's still. It was about 10 a.m. when the story-and-a-half bungalow exploded, driving the structure's front door into the house across the street.

Engine 78 pulled up and immediately dropped two lines of 2 1/2-inch hose. It was a very cold day as they continued to pour water on the burned-out building. As the roof caved in, the house started leaning toward the street. Dad was on the parkway portion of the property, heeling his line, when he noticed the house falling toward him, almost in slow motion. Mesmerized, he never moved an inch, but after it had settled, the peak of the roof landed about 18 inches in front of him. What was left of the collapsed house was no more than 2 feet thick.

The neighbors told them that an older man and woman lived in the house. Engine 78 was not allowed to go home—even though the fire was struck out—until they found the bodies of the victims. The man was discovered immediately inside the front door. They figured he was a coin collector, as pieces of his collection were found scattered in the debris. These personal belongings were gathered up for the police to handle. It became colder and colder as they continued

to search for the missing woman's body. It was late afternoon when Dad noticed something by Firefighter Dick Stull's foot. . . it was an ear. After some digging, it was determined that the old woman was indeed buried there under the rubble. The victims found and the fire out, 78 could finally go home.

So far, Engine 78 has been shown as they have responded to their runs, fighting fires "by the book." Sometimes this simply does not work. Engine 78's biggest blunder occurred during a run to a building on the east side of Clark Street. When they arrived, black smoke was pouring out of every orifice—including the roof. The guys broke two glass entrance doors to get inside the building, only to find three stairs that ended at a wall, going nowhere. It was like a building within a building. They continued to break glass to search for the fire. There was a print shop on the second floor. The responding truck company was on the roof cutting holes trying to ventilate, but they still could not locate the cause of the fire, and thick black smoke continued to pour out. Meanwhile, a squad company had arrived in the alley and cut through some aluminum doors. Inside was a furnace no larger than 2 feet in diameter with a fire in its motor. This was the source of the awful black smoke. A hand pump easily took care of the fire, but by this time, the building had been destroyed.

The owner of the building showed up at 78's door a few hours later, demanding an explanation. He was very calmly told to see the battalion chief over at Truck 21's house. There he would receive full details on what had happened. Given the circumstances of the fire, E78 did nothing wrong by giving it their best shot, but they couldn't prove it to this poor property owner.

Sometimes a fire company's best goes beyond the call of duty. Engine 78 has always been a busy company by anybody's standards. One day was particularly busy, as they caught runs one after another all day

and into the night. They had already logged something like 22 runs for the shift when they dragged themselves back home around 5 a.m. Like zombies, the men headed off to the bunk room to try to get a couple hours of rest. My dad had last watch.

Watches on the CFD are determined by the men and can vary by firehouse. The officer in charge usually stays out of the process unless there is a dispute. Engine 78 had four watches then: 10 p.m. to 1 a.m., 1 a.m. to 3 a.m., 3 a.m. to 5 a.m., and the last watch began at 5 a.m. It was the responsibility of the man on last watch to clean the kitchen, sweep up, do the dishes, and make coffee, so not only did Dad have to stay awake and listen to the sounder, but he had to tidy up

the place as well. His bones ached as he heard E83 to the north go out on Wilton to their still. He prayed with all his heart it wouldn't go to a box, as 78 would have to follow, but his luck ran out and it did. The boys went out the door yet again.

Frustrated and tired, Dad pulled hose to a third-floor apartment up the back stairway and ruptured himself doing it. He darkened the fire and just wanted to go home, but Chief Miele had other ideas. He said that another box was going only a block away, and he wanted 78 to be there. They left their hose at the first location, intending to pick it up later, and went to fight yet another fire. When they didn't think they could go another step, somehow they kept going. They fought two more fires because they were needed. That's when firemen had leather lungs and brass fittings.

Pictured here is the author, a couple of days after the big snow of January 1967. The snow was too deep and dangerous for an eight-year old girl.

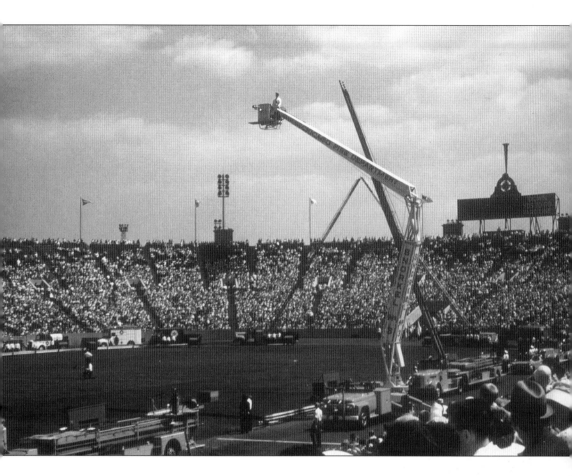

Showcasing the newly invented snorkel at the Fire Department Thrill Show held in 1960 at Soldier Field.

CHAPTER 6

ANGELS AND AWARDS

An "angel" is defined as a messenger of God, or a kind and lovable person. Many people in and around the fire department can certainly be considered angels.

The most obvious reference is to firemen themselves. They risk their lives every day to help those in need, often at the expense of their own personal safety. A fireman's role in the field is well known to the general public, but they also help the community in more subtle ways.

All firehouses are first aid stations. At any time, anyone can walk into a firehouse and receive medical attention. The kids of the neighborhood around 78 would often come in with scraped knees and minor cuts. The wounds were cleaned up, a Band-Aid applied, and the happy kid would run off again to play, but unfortunately these neighborhood mishaps were not always minor.

Once, Jimmy Stewart and my dad were sitting in front of the firehouse on a warm summer's day, when a child came running down the street with his arm flopping from side to side. It was obvious that his arm was broken, and he was doing more damage to it by allowing the arm to dangle. Stewart immediately jumped up and ran toward the kid, meeting him halfway down the block. He was quickly placed in the ambulance and taken for the emergency care he required.

On another summer day during Cubs batting practice, around 10 a.m., a batted ball came over Wrigley's left-field fence without warning and smacked a kid right between the eyes as he crossed Waveland on his way to the ballpark. Ambulance 6 was out on a run, so another ambulance was called, but he was well taken care of by 78's firemen until it arrived. Again, the guys just happened to be in the right place at the right time, to help when they were needed the most.

At a fire, firemen are thankful to angels of mercy who help them in various ways. For spiritual inspiration and help, there are fire department chaplains. Chaplains are provided for those of the Catholic,

Protestant, and Jewish faiths. It is the chaplain's duty to aid everyone who needs his counsel—including firemen and victims. Death and suffering do not know rank.

Father Matthew McDonald often went into fires dressed very much like a firefighter, wearing his white fire coat and helmet, displaying a cross and the word, "Chaplain" on the shield. At one particularly smoky fire, Dad was helping to remove a victim, zipped up in a body bag, down a stairway. Father McDonald met them halfway up the stairs and insisted that they put the bag down right then and there in the choking smoke. The firemen warned him that the contents of the bag were not pretty, but the Father insisted, opening the body bag and giving the charcoal-like corpse its last rites. This was still a person and deserved to be treated like a child of God.

The chaplain took care of the soul, but for creature comforts, the Salvation Army was present at any fire of a 2–11 magnitude or higher. Long before the Army had their own canteens, they used buses provided by the city for warming stations in which to serve coffee, donuts, sandwiches, and soup to the weary, cold firefighters. At 8 p.m. on a warm summer evening, there is an abundance of nosy gawkers at an extra-alarm blaze, but at 3 a.m. when the temperature is subzero, no one can be found—except for the Salvation Army. Besides the much-needed warmth and sustenance for a few minutes, they also provided dry cotton gloves. To a frozen hand these feel wonderful, even if only for a few moments until they became wet and froze once again.

Another group who often helps firefighters is known as "fans." These are individuals who love the fire department and usually hang out in firehouses whenever possible, but for one reason or another never joined the department. Some firefighters actually start as fans. Many fans keep their own fire boots and coat in the trunks of their cars at all times, then respond to fires to help pick up hose or offer other

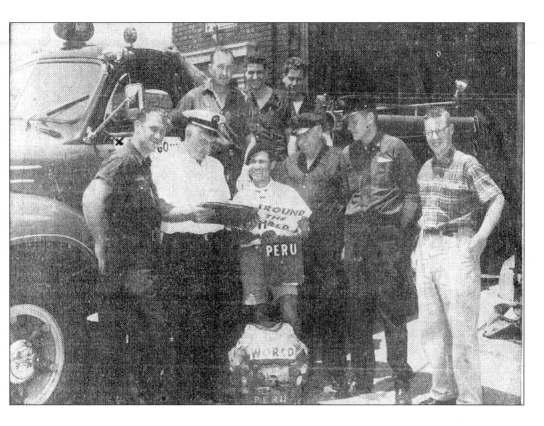

A lighter moment is shared outside Engine 78's quarters with visiting volunteer firefighter Alex Sanchez from Ica, Peru, during his attempt to walk around the world. He was two years into his quest when this picture was taken in 1960. (Source unknown.)

assistance. After an extremely long battle fighting an extra-alarm fire, another pair of hands to help roll up hose is most welcome. Art and Junior Thompson used to do one heck of a job, often picking up more hose than some firemen. Art finally realized his dream after many years and became a firefighter.

Back at the house, fans often helped to hang the heavy, wet hose in the hose tower when the tired firemen returned home. If the fan did not follow to the location of the run and remained in the house, he would often close the overhead door behind the engine, tend to dinner in the oven, or have hot coffee ready when the rig backed in after the call. Many fans knew the sounder and general procedure of the firehouse better

than most candidates, and they were often a very welcome addition.

Also greatly appreciated were retirees. Sometimes a guy would retire but had nowhere to go. Perhaps his kids were married with families of their own or his wife deceased. He was lost without the fire department in his life and would ask the captain if he could live in the firehouse. More often than not, the captain agreed. An extra bed in the bunkroom would be designated as his, as well as a locker. He would find an old wooden dresser in which to keep a few personal things and put it by his bunk. This became his life. Like the fan, he would also close doors after the rig, make sure dinner didn't burn, make coffee, and clean up around the house. He could also be counted

on to act as a "gopher," going on errands for cigarettes or a newspaper. This was his family and the place in which he belonged.

The firemen at 78 were definitely like "family" in many ways. Harry New York, who we met briefly earlier, was an orphan. No one really knew where he came from, but he had no family to speak of. The firemen at 78 took him under their wings. While living at the firehouse, he attended grammar school and high school just like any other kid, the firemen often helping him with his homework and providing a stable "home" life for him. When it was time for him to make it on his own, he landed a job across the street at Wrigley Field, where he worked for over 40 years. The firemen raised this boy to be a well-adjusted, independent man.

With guys coming and going all the time, the firehouse often took on a clubhouse-like atmosphere. Like kids in a tree house, firehouse life was filled with camaraderie and brotherhood. Engine 55's quarters nearby housed a handball court, which was always in demand. Reservations had to be made well in advance to play there. Even the local parish priest wanted in on the competition. At 78, a good card game or Cribbage tournament could always be found late in the afternoon after all the housework was done. Arguments would erupt over who did what, but it was all in good fun and in the name of healthy sportsmanship.

Besides being "brothers" to each other, the fire department—especially individual houses—played ambassador to the world. Alex Sanchez, a 4-ft. 8-in., 118-lb. volunteer fireman from Ica, Peru, began a journey to circle the globe on foot April 15, 1958. Along the way, he stopped at many firehouses, 78 being one of them, where he was graciously put up for the night. A publicity shot in the local paper showed Alex posing in front of the engine, while sharing his scrapbook of world travels with the guys.

The character of the men of Engine 78 and

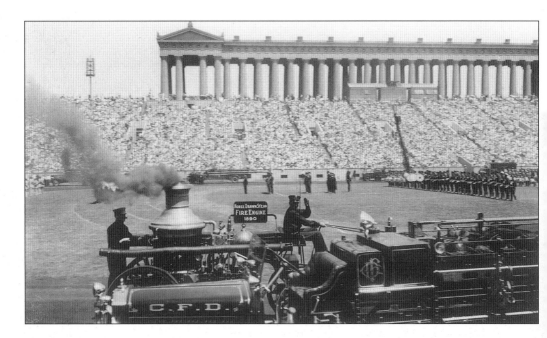

These three pictures were taken at one of the combined Fire and Police Department Thrill Shows, held in the '40s at Soldier Field. Credit goes to my grandfather for taking these magnificent shots. Featured were old fire equipment and police on horseback.

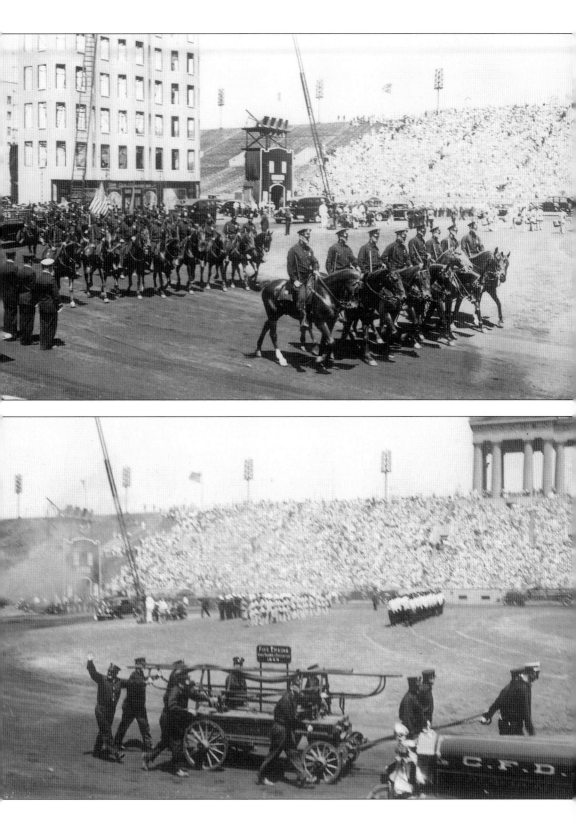

Ambulance 6 can best be exemplified by the events of one cold Christmas Eve. Around 5:30 in the evening, a man came into the firehouse and asked Lt. Marshall if he could have a leftover crust of bread. He had nothing. The boys could do much better than that, and they decided that Illinois Masonic Medical Center could probably provide a better holiday meal for this man and his family. The ambulance was put on the air, and Jimmy Stewart took him to the hospital. Luckily, the superintendent was still there and gladly provided a full meal of turkey, potatoes, sweet yams, cranberry sauce, bread dressing, a casserole of rice pudding, and two pumpkin pies. When he realized the man was also out of work, he told him to come back after the holiday, and a job would be waiting for him at the hospital. The man was elated and thanked them over and over. Just as the goods were being loaded into the ambulance, he was asked if he had any children. Yes, he had two. The hospital generously donated some toys for them. He and his family would have a truly Merry Christmas. Upon returning to the firehouse, the food and presents were transferred from the ambulance to Johnny Bray's car. He escorted the man to his home to help him unload the Christmas bounty. As the man knocked on his door, he cautioned his wife not to yell at him for being late because he had someone with him. Inside, the apartment was cold and dreary, and it was obvious that the family needed this help. Wishing them a Merry Christmas, Johnny left the family and returned to the firehouse. Two days later, the man never showed up for the promised new job at the hospital. When the apartment was checked, it was empty, abandoned. No one ever found out what happened, but the members of Engine 78 and Ambulance 6 knew that they had tried to help someone in need.

We have now come full circle from firemen taking on a motherly role and fixing scraped knees, to acting like kids themselves playing in their clubhouse, but their camaraderie does not stop when the shift is over. When teamwork counts, they really know how to pull together. Such was the case when the Fire Department Thrill Shows were presented at the majestic Soldier Field.

The original Thrill Shows, staged annually from 1937 until the start of WW II in 1941, were joint ventures with the police department and sponsored by members of the Chicago media. They were stopped for the war effort and finally resumed in 1958, but this time they featured only firefighters. Tickets for this premier performance sold for $1 apiece, with proceeds going to the Chicago Firemen's Fund to benefit the widows and orphans of deceased firefighters. This first show was so popular that 30,000 people were turned away at the gate. This prompted officials to stage two shows in 1960, and three in 1962.

These three-hour extravaganzas delighted the crowd with demonstrations of raising ladders, jumping into nets, extinguishing various types of fires, battling in an old-fashioned water fight, and featuring many precision stunts. The show began with a parade of fire apparatus, starting with a model used during the Great Chicago Fire. Performances were also given by the Chicago Fire Department Glee Club and the famed Band and Drill Team. The crowd cheered when the Drill Team used cards to spell out "CFD" on the field. Mayor Richard J. Daley and Commissioner Robert J. Quinn presided over the ceremonies.

A Fire Alarm Office was created in a corner of the stadium to simulate fire alarms being received. The audience heard the alarm ring in a false firehouse across the field, where firefighters would immediately respond to the mock alert. This configuration effectively demonstrated how calls came in and runs were dispatched.

The newly formed clown troupe, the "Five Funny Flames," included Engine 78 firefighter Gus Aparo as "Smoky." The clowns proved to be so popular that they often performed at other civic events throughout

the year. In one sketch, the funny men dressed up as women firefighters, calling themselves the "Fire Belles," complete with pin curls and pink girdles. They spoofed how women would respond to a fire, stopping to make sure their hair was fixed and make-up was on before racing to the fire on a flowerpot and frilly curtain-covered fire engine. It was hilariously funny, and of course 40 years later, is the furthest thing from the truth.

My family attended one of the 1960 presentations of the show when I was two years old. I remember Gus motioning to me in the stands to meet him at the edge of the infield. I was sure that everyone in the stadium was watching me as I carefully negotiated the stone steps. To my delight, Gus gave me a handful of uninflated balloons. It felt so special to know one of the clowns!

There was lots of clowning around at these events, but firefighting is serious business that requires split-second timing. No place was this more evident than during the engine race. Engine 13 and Engine 78 were chosen to race each other since they were the only two engines in the city, at the time, to carry booster pumps, which used on-board water. The race began at the sound of the bell, then each engine traveled in opposite directions around the track, until they arrived back at the starting point deploying their water to win. The precision of Engine 78's men showed time and time again, as they always proudly won this impressive contest!

The highlight of the event was the simulation of a large fire burning in a four-story building facade, erected at the north end of the stadium. Marines were perched in the upper windows with flame-throwers, creating plenty of fire and smoke. Snorkels and other fire equipment responded to the mock blaze in a spectacular show of efficiency and effectiveness.

The Thrill Shows were always a crowd-pleasing event and brought acclaim to the

These pictures were taken at the Fire Department Thrill Show held in 1960 at Soldier Field . . . long before it had skyboxes!

Notice Engine 78 here in the foreground of these two pictures, taken at the 1960 CFD Thrill Show. The classic red and black sedan of Ambulance 6 is following close behind. Notice the two beds of hose the rig carried in the '50s and '60s, compared to the three beds of hose they carry now.

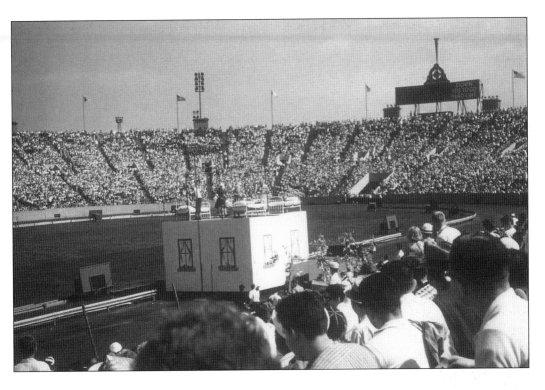

Here the Fire Department Clowns, knows as the "Funny Flames," spoof being the "Fire Belles," acting as they envision women firefighters would respond to a fire—complete with pink girdles and pin curls in their hair. They fix their faces before jumping on a flowerpot and frill-covered engine to answer the call.

Chicago Fire Department as a whole, but the department is made up of individuals, many of whom deserve their own special awards.

The Lambert Tree and Carter H. Harrison Medals are civilian awards given annually to an individual member of the police and fire departments who demonstrates outstanding bravery in the line of duty. Currently, the medal presentations are rotated from year to year, so neither award is perceived as better than the other. The awards are given out during Fire Prevention Week in October each year for the preceding 12 months. In 1999, the fire department designee received the Lambert Tree Award; therefore, in October 2000, the department recipient will receive the Carter H. Harrison Award.

The Chicago City Council established the awards on November 9, 1885, upon receipt of a $700 donation from Mayor Carter Henry Harrison and Judge Lambert Tree, specifically to honor annually the gallant and meritorious service of one member from each the police and fire departments.

Carter H. Harrison (1825–1893) was mayor of Chicago from 1879–87, and again in 1893. He brought Chicago to international notoriety by hosting the Columbian Exposition, the World's Fair of 1893, and he was assassinated by a disgruntled office seeker the day before the fair ended. His son's name appears on the plaque at Engine 78's quarters. Carter H. Harrison II was mayor when the brick firehouse was built in 1915.

Judge Lambert Tree (1832–1910) was a Chicago Circuit Court judge who achieved fame by presiding over the indictment, trial,

The highlight of the Thrill Show was always the fire started in the mock building at the north end of Soldier Field. Marines stood in the windows with flame-throwers, while fire apparatus raced to the scene to extinguish the blaze to the cheers of the crowd.

and conviction of corrupt city council members. He lost the 1882 U.S. Senate race by one vote, but in 1885, he accepted an appointment from President Grover Cleveland as minister to Belgium.

The Lambert Tree and Carter H. Harrison Awards have been presented annually (with the exception of the years 1890–1896) since the first was bestowed on Edward W. Murphy on March 4, 1887. Fifth Battalion Chief Murphy received the Carter Harrison Medal for four separate acts of bravery for rescues occurring in 1886 and early 1887.

On September 11, 1915, Lt. Cowhey of Engine 92 was detailed to Engine 78 for the day. On the morning of the 12th at 3:35 a.m., he responded to a fire at 3632 North Wilton Avenue, where he rescued a woman and child from the third floor of a burning building, using a 16-foot ladder. For this brave action, he received the Lambert Tree Award.

The Chicago Fire Department has been proud to have many types of heroes serving in its ranks. The only firefighter to ever receive the Congressional Medal of Honor was Joseph McCarthy from Truck 11. A captain in the Marine Corps, McCarthy achieved the honor when he aggressively led the attack and capture of a Japanese stronghold on Iwo Jima during WW II, February 21, 1945. He retired from the military as a colonel, then returned to Chicago and the CFD to resume his career, where he was immediately elevated to the position of Director of Ambulance Services. In this position, he revamped the entire ambulance service, creating one of the largest and most efficient organizations in the nation. He often stopped at Engine 78's quarters to visit Captain Gibbons and the men of Ambulance 6.

Other heroes die in the line of duty. On July 23, 1998, around 10 p.m., Engine 78 responded to a 2–11 at a building undergoing renovation at 4837 North Kenmore Avenue. While dragging heavy hose into the structure, 54-year-old Captain Tom Prendergast suffered a heart attack. He was

Captain Tom Prendergast of Engine 78 tragically died due to complications from a heart attack he suffered while fighting a fire. The portion of Seminary Avenue running along the firehouse has been renamed in his honor.

immediately rushed to Illinois Masonic Medical Center for treatment. While recovering, the Cubs organization wished him well during a baseball game broadcast on WGN-TV and also sent him a get-well card. Captain Prendergast was sent home from the hospital to fully recuperate, but unfortunately he died August 24, 1998, from complications. In his honor, a brown street sign with white letters perched on the light pole outside the firehouse proclaims a section of Seminary as "Captain Tom Prendergast Drive." Inside, a metal plaque displayed on the wall next to the officer's desk gives details of the captain's last run

and serves as a further tribute to the brave firefighter.

Sometimes it's the least likely who become heroes. Spike was a black six-month old mutt who lived at 78 and was a brat. He quickly learned to jump on the engine when the bells rang to head out with the boys on a run. Unlike his predecessor, Pat, he did not like to stay with the engine while the guys were busy fighting fires. Pat would protectively guard the engine, baring his teeth if anyone came near, but Spike preferred to run all over the place. On a run to a swanky Lake Shore Drive apartment building, Spike romped around the lobby, jumping on the couches and misbehaving like a puppy, then he silently slipped into the elevator with the firemen for the ride up to the fire. Hours later, when the fire was over and they were back home, it was discovered that Spike was missing. Everyone remembers him coming home with the engine, but somehow the little sneak had gotten out. Minutes later, the doorman from the fancy place on Lake Shore Drive was on the phone. Spike had returned and was bouncing through the lobby again, but he had finally settled down to sleep on a comfortable couch. The doorman wanted someone to come pick up the wayward dog. Spike always seemed to be in trouble.

On one particular run, Spike rambunctiously jumped off the engine as usual and ran up the gangway ahead of the firemen. Unbeknownst to them, a power line had fallen in the backyard over a metal cyclone fence, electrifying it. Spike was electrocuted on contact, saving the lives of the firemen in the process. This little pain-in-the-neck dog was a hero.

As we've seen, angels and heroes come in all shapes, sizes, and species, but they all deserve our gratitude and appreciation for a job well done.

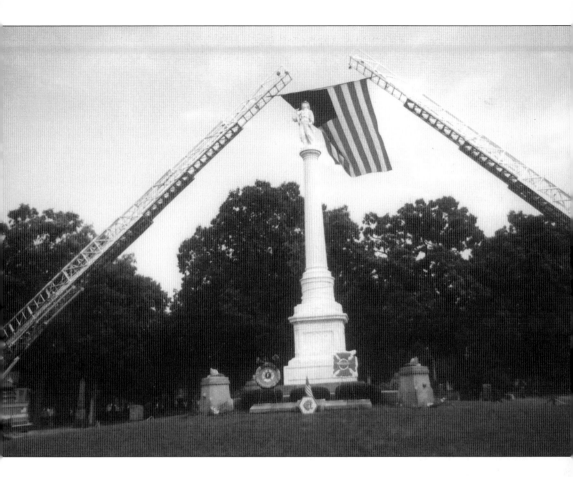

Held at Rosehill Cemetery annually is a ceremony for firefighters, active and retired, who died during the preceding year.

CHAPTER 7

HISTORIC CEMETERIES
AND THE CFD

Engine 78 sits in the middle of an historic area of the city known as Lake View. One of the most notable areas she serves is Graceland Cemetery, the final resting place of many of the city's early movers and shakers.

Graceland was established in 1860, to fill the need for a cemetery outside the city. The old City Cemetery, now known as Lincoln Park, was too close to Lake Michigan, and it was feared that the inundating waves washing over the graves during storms was contaminating the water supply with disease. In an effort to prevent an epidemic, bodies were relocated to two new cemeteries far from the lake water—Rosehill Cemetery a few miles to the north, and Graceland Cemetery conveniently located just north of Chicago in Lake View.

The entrance to Graceland Cemetery is on the northeast corner of Irving Park Road and Clark Street, a few blocks north and slightly to the west of the firehouse. It is important that the cemetery have adequate fire protection, since not everything is made of burn-proof granite. A typical call to a cemetery is usually due to a car fire or the occasional grass fire, but large mausoleums can contain rugs and other flammable furnishings. In these cases, the booster tank on the engine is extremely handy since there are generally no fire hydrants in a cemetery, and a hand pump may not always hold enough water to extinguish the blaze.

Graceland is home to many of the famous people important in Chicago history. John Kinzie (1763–1828) was the first white settler in Chicago, arriving in 1804. His remains were moved quite often before finally finding rest here. He was originally buried in the Fort Dearborn Cemetery, then moved to the city burial grounds, then moved once again to the City Cemetery before finally arriving at Graceland.

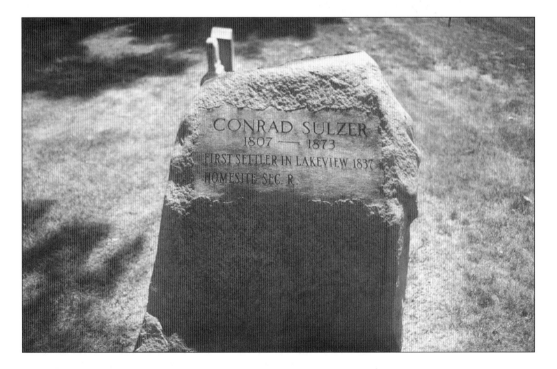

Conrad Sulzer was the first settler in Lake View, and he is buried here in Graceland Cemetery.

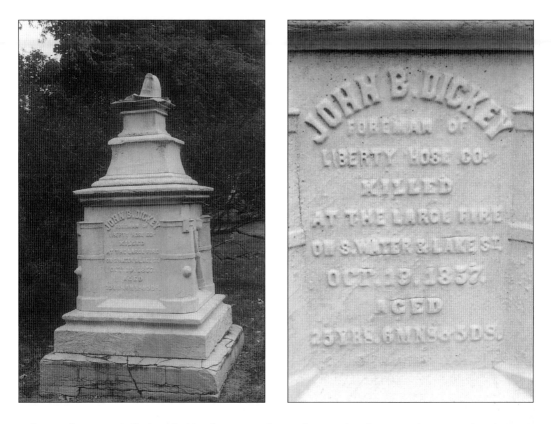

John Dickey was killed with 22 others at a large fire on South Water Street on October 19, 1857. His memorial details his death. This prompted Mayor "Long John" Wentworth to push for a professional fire department in Chicago. The next year, on August 2, 1858, the professional Chicago Fire Department was born.

The first settler in Lake View in 1837, Conrad Sulzer (1807–1873), is buried under a large hunk of rock. His original residence was located at the northwest corner of the current Graceland Cemetery. That same location was once the southeast corner of old Green Bay Road (now Clark Street) and Sulzer Road (now Montrose Avenue). A few blocks to the west along Montrose, the Sulzer Regional Library is dedicated in his honor.

On October 19, 1857, John B. Dickey, a volunteer Chicago firefighter, was killed at a large fire at 109–11 Water Street, where 22 other firefighters and civilians also lost their lives. This inferno prompted Mayor "Long John" Wentworth to push for a paid, professional fire department in the City of Chicago, even though it was politically unpopular at the time. Dickey's monument is quite impressive, fashioned out of mostly white stone in a series of pedestals piled upon a marble base. It stands about 6 feet tall with a lonely fire helmet, also in white, perched on top. The worn, raised letters on his memorial vividly tell the story of his death, "John B. Dickey, Foreman of Liberty Hose Co: Killed at the large fire on S. Water & Lake St., October 19, 1857, Aged 25 yrs. 6 mns. & 5 ds."

Buried not far from Dickey lies Edward O'Neil (1843–1897), another firefighter. Crafted of smooth, black-speckled granite, O'Neil's marker looks similar to a tall

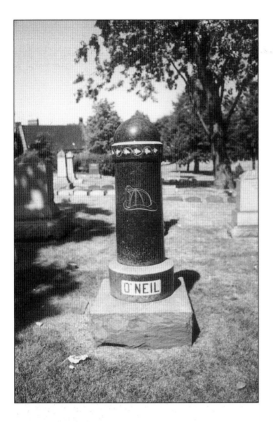

Firefighter Edward O'Neil (1843–1897) probably served during the Great Chicago Fire of 1871.

fireplug. Etched simply in white on the side of his memorial is a classic fire helmet, while an elegant vine pattern decorates the top. The dates indicate that O'Neil probably helped fight the Great Chicago Fire of 1871.

Hotelier Dexter Graves (1789–1844) brought the first colony of settlers to Chicago from Ashtabula, Ohio, in 1831. What is unusual about his grave is the statue entitled "Eternal Silence" by Elmwood Park, Illinois-born sculptor Lorado Taft. This robed figure, portraying death, has turned green over time, but his eerie hooded face remains a mysterious black, giving the piece an otherworldly effect. Legend has it that anyone who gazes into the face of the 8-foot statue will see visions of their own death.

Also buried here are the great benefactors

Carter H. Harrison and Lambert Tree, originators of the civilian awards for heroism, discussed earlier, given to fire and police personnel every year.

Carter Henry Harrison (1825–1893) is buried near an impressive stone obelisk, designated as the family memorial. Harrison's name appears in large, bold, raised letters on the front of the monument, while names of other family members are inscribed simply on the side one after the other. Harrison and his son were both Chicago mayors, each serving several terms. As we learned earlier, Carter H. Harrison II (1860–1953) is noted on the plaque outside Engine 78's quarters since he was mayor when it was built in 1915.

Judge Lambert Tree's (1832–1910) grave site is simpler, but very elegant. A large upright slab of highly-polished black granite sitting on concrete steps marks the Tree family burial site. Lambert's modest individual marker lies directly in front of it on the far left side, also in black granite.

North of Lambert Tree lies Joseph Medill (1823–1899), elected mayor of Chicago as the "fireproof candidate." As mentioned earlier, his legacy was the change to the fire codes after the Great Chicago Fire of 1871. His family monument is built of sturdy gray granite, in a series of square blocks piled on stone steps. "Medill," spelled out in raised letters, appears on the front of the massive marker, with individual stones for family members surrounding it. The only fireboat currently in use, *The Joseph Medill*, known as Engine 37, is moored at the Franklin-Orleans Bridge.

Across the road from Tree and Medill is a little island of lawn showcasing Graceland's only mausoleum with Chicago Landmark status. Henry Harrison Getty (1838–1920) commissioned Louis Henry Sullivan to create this unique tomb for his wife, Carrie Eliza Getty in 1890. The structure was designated a city landmark in 1971, by Mayor Richard J. Daley, as it exemplifies "the beginning of modern architecture in America." The tomb

is cube-shaped, with elaborate concentric arches above the door and around the sides. The bottom half is relatively plain compared to the intricate carved detail of the upper half of the structure. Two heavy, ornamental bronze gates, now turned green with age, created with fancy floral and geometric patterns, stand before an equally impressive sculpted door.

Graceland is an excellent example of a traditional Victorian cemetery. It is meant to be a place of peace, tranquillity, and beauty. Daniel Hudson Burnham (1846–1912) is responsible for the beautiful parks we have along Chicago's lakefront today, just as he envisioned in "The Chicago Plan of 1909." It is only fitting that Burnham is buried under natural glacial boulders, taken from the shores of Lake Michigan, on his own tiny island at the north end of Graceland's Lake Willowmere. Here he lies surrounded by the park-like beauty he loved so much.

Across the small lake stands the extraordinary Greek temple-like structure of Potter Palmer (1826–1902) and his socialite wife, Bertha (1850–1918). Palmer was responsible for making Chicago's State Street "that Great Street," building the first Palmer House Hotel in 1870. The eight-story building was burnt to the ground during the Great Chicago Fire a year later, but Palmer continued to build his empire and became quite wealthy. The Palmers are buried within two magnificent granite sarcophagi, with inverted torches representing death intricately carved at the corners of each. These lie under an ornate roof supported by 16 great pillars, giving the structure an old-world Parthenon look. Three generations of Palmers are buried beneath the concrete floor, each identified along with their year of death chiseled in Roman numerals. It is by far the most colossal monument at Graceland and is perhaps proof you "can" take it with you.

The merchant Marshall Field (1835–1906) is buried here as well. The sculpture entitled "Memory" sits behind a small reflecting pool.

The statue consists of a seated, forlorn-looking woman dressed in robes holding oak leaves signifying courage in her right hand. On the base of her throne are two representations of the caduceus, the Roman god Mercury's winged staff with two intertwined serpents, representing commerce. Ten years after this sculpture was designed by Daniel Chester French and Henry Bacon, they went on to create the Lincoln Memorial in Washington D.C.

The much hated George Pullman (1831–1897), inventor of the Pullman sleeping train car and builder of the town of Pullman to house his workers, is buried beneath a towering Corinthian column, his

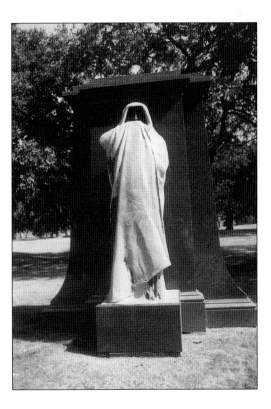

Elmwood Park native Lorado Taft created this statue entitled "Eternal Silence." The 8-foot sculpture stands in front of the grave of hotelier Dexter Graves, who brought the first group of settlers to the area from Ohio in 1831.

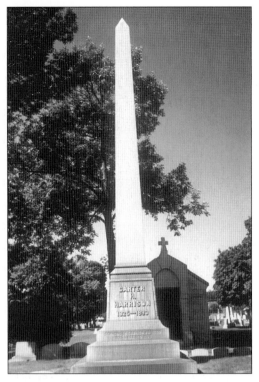

Carter H. Harrison and his son were each mayors of Chicago for multiple terms. The Harrison family is buried around this stately monument, each with their individual marker.

Lambert Tree was a circuit judge of Chicago and is buried beneath this modest stone. His family marker is simply a large piece of polished black granite. Each year, the Carter H. Harrison and Lambert Tree Medals are given to a member of both the fire and police departments for heroism performed in the line of duty.

Joseph Medill, former owner of the Chicago Tribune *newspaper, became mayor of Chicago after running on the "fireproof" ticket following the Great Chicago Fire of 1871. The only fireboat still in use today by the CFD, Engine 37, is named* The Joseph Medill.

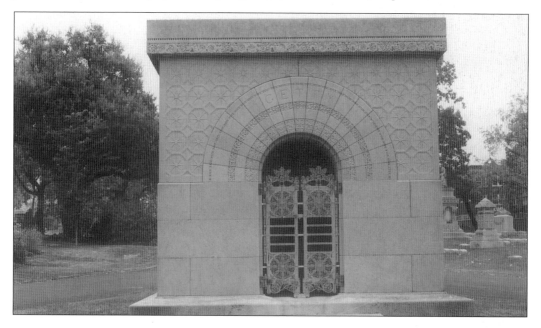

The Getty Tomb is the only mausoleum in Chicago to have received Chicago Landmark status. The innovative Louis Sullivan created this masterpiece in 1890. It is considered to exemplify the beginning of modern architecture in America.

Daniel Burnham is responsible for Chicago's gorgeous lakefront, devoid of wharfs, but full of parks. He is buried under natural glacial boulders taken from Lake Michigan on his own island, pictured here, in Lake Willowmere in Graceland Cemetery.

coffin wrapped in tar paper and enclosed in a room-sized block of concrete reinforced with railroad ties. When the Pullman Company came upon hard times, Pullman reduced the wages of his workers but insisted they still pay him the normal rent on their homes. Many workers ended up owing Pullman money every month and hated him for it. After Pullman's death, it was feared that his body would be stolen by his disgruntled workers and held for ransom, so the family went to these extreme measures to make sure Pullman's remains could never be moved.

The list of famous Chicagoans buried at historic Graceland just seems to go on and on. Individuals buried here include: *Chicago Daily News* founder, Victor Lawson; piano manufacturer William Kimball; the world's first private detective and founder of the U.S. Secret Service, Allan Pinkerton; inventor of

the reaper, revolutionizing agriculture, Cyrus McCormick; meat-packer Philip Armour; heavyweight boxing champions Bob Fitzsimmons and Jack Johnson; many early visionary architects; an Illinois governor; ten Chicago mayors; and many more.

One of the more intriguing graves, although perhaps not as famous by name, belongs to William A. Hurlbert (1832–1882), founder of baseball's National League. When he and Al Spalding, new pitcher-manager of the White Stockings, organized the league in 1876, there were only eight teams, four from the West—Chicago, Cleveland, Buffalo, and Detroit—and four from the East—Boston, Providence, Worcester, and Troy. Hurlbert served as league president from 1877 until his death in 1882. His marker is a large granite baseball more than a foot in diameter, with all eight league teams spelled out in raised, polished granite letters. The

White Stockings' descendants, the Chicago Cubs, play at Wrigley Field, a few blocks away.

Perhaps the most tragic and haunting monument belongs to the Hoyt family. William M. Hoyt (1837–1925) was a prosperous wholesale grocer originally from Vermont, who, like many, lost everything in the Great Chicago Fire of 1871. Saddened, he fought back after the fire but was thrown into even greater despair when he lost his daughter, Emilie, and her three children in the Iroquois Theater Fire on December 30, 1903, which claimed 601 lives. His grandchildren, aged 15, 12, and 9, are buried in a row next to their mother, all of the markers bearing the same gruesome date of death. Emilie's husband, Frederick Morton Fox, died only a few months later, unable to overcome his intense grief.

The large, ornate memorial expertly displays typical Victorian funerary art, three female figures gracing the top of this lavish memorial. The uppermost woman clutches a large cross to represent faith and salvation, the second holds an anchor as a symbol of hope, and the third nurses a child to represent love and regeneration.

This incredible 119-acre, living museum with all its history and fine works of art is protected from fire by the humble Engine 78, just down the street. Also in the district, and full of history, is Wunders Cemetery, located directly across Irving Park Road to the south.

Wunders Cemetery is older than Graceland, established in 1859, but is often overlooked due to its small 14.5-acre size. It was originally known as the German Lutheran Cemetery and was part of the

Potter Palmer is famous for his Palmer House Hotel. His first was 8-stories high, but it burned to the ground shortly after opening due to the Great Chicago Fire. This opulent Greek-style temple is perhaps proof that you can take it with you. Potter and his society wife, Bertha, are buried in matching elaborate sarcophagi.

The statue "Memory" graces the resting-place of famous merchant Marshall Field. After designing this memorial, Daniel Chester French and Henry Bacon went on to create the Lincoln Memorial in Washington D.C., ten years later.

George Pullman is buried under this impressive monument in a room-sized block of concrete reinforced with railroad ties. He was so mean to his workers at his Pullman Sleeper Car plant, it was feared that his body would be stolen and held for ransom.

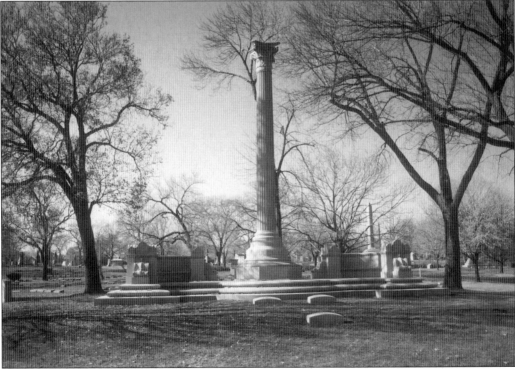

William A. Hurlbert, founder of baseball's National League, is buried by a baseball more than a foot in diameter. All eight teams in the league at the time are represented in raised granite letters on this unique marker

Many of the monuments at Graceland Cemetery have an historical connection to Chicago. The Hoyt Memorial represents the grief suffered after Emilie Hoyt and her three children were killed in the Iroquois Theater Fire of 1903. Her husband died a couple months later of a broken heart.

The intricate statues on top of the Hoyt Memorial represent faith (woman on top with cross), hope (woman on left with anchor), and regeneration (woman nursing baby).

Church of St. Paul, the oldest Lutheran church in Lake View. In 1919, the cemetery was renamed Wunders, after the pastor of the church. Many of the inscriptions on these haunting graves are written in German, a reminder of the rich ethnic, working-class heritage of the area. These two cemeteries are quite different, but they lie side by side along Clark Street, separated only by Irving Park Road.

Although located out of 78's district a few miles further to the north and west, Rosehill Cemetery at 5800 North Ravenswood also has significance to the CFD. Established in 1859, like Graceland, to relieve the overcrowding and health hazard created by the old City Cemetery, Rosehill is the city's largest at 350 acres. Located on the city's highest elevation at 672' above sea level, this area was previously known as "Roe's Hill," named for a nearby tavern owner, Hiram Roe. A mapmaker's error resulted in "Rosehill."

Approaching from the east down Rosehill Drive, the first noticeable feature of the cemetery is the impressive castle-like facade, resembling Chicago's beloved Water Tower, which survived the Great Chicago Fire. Made of the same Joliet limestone, both structures were designed by the same architect, William W. Boyington (1818–1898), but Rosehill's entrance was built five years before her famous cousin. Erected in 1864, the castle facade was given Chicago Landmark status in her own right in 1980. William Boyington is also buried here not far from the front gate, beneath a modest marker next to other family members.

Directly ahead of the front gate up a short road sits the inspiring Soldier's and Sailor's Monument entitled, "Our Heroes," designed by Leonard Volk. A bronze plaque affixed to each side pays homage to the Calvary, the Infantry, the Artillery, and the Navy. Each year on Memorial Day, Civil War re-enactors gather at this spot to remember our war dead.

Looking north down another short road stands a similar monument, also designed by

Rosehill Cemetery's facade is impressive. Made of the same Joliet limestone as Chicago's beloved Water Tower that survived the Great Chicago Fire, it was also created by the same architect, William Boyington, five years earlier in 1864. It was given Chicago Landmark status in 1980. Boyington is buried inside to the left, not far from his famous front gate.

Rosehill Cemetery has the distinction of having the only monument dedicated to the volunteer firefighters of Chicago. The impressive memorial sits on its own island, not far from the front entrance.

Volk. The Volunteer Firefighter's Monument pays tribute to the volunteer firemen who bravely served Chicago. Erected in 1864, it is the only memorial of its kind to honor these special men.

Situated on its own island of raised earth, the stark white structure rises eloquently skyward. A statue of a volunteer firefighter in full gear stands proudly on top of the single classic column, stoically gazing out over the cemetery, a bugle clutched in his left hand held by his side, and a coil of hose looping his right shoulder.

Etched into the smooth marble base are the words, "In Memory of Members of the Volunteer Fire Department." Directly in front

lie three polished granite slabs, those on either end listing the 18 names of the men interred beneath the monument that died in the line of duty. The center stone proudly proclaims, "This monument was erected in 1864 to honor all the courageous volunteer firefighters of Chicago. Rededicated October 7, 1979, Chicago Firefighters Union, No. 2."

Surrounding the inspiring memorial on four corners are concrete copies of old-style square fire hydrants. On top of each sits a stone fire helmet, weather-beaten with age. Fence sections made from cotton-woven jacketed hose nailed to wooden posts guard the edge of the grassy knoll, providing the perfect setting to pay tribute to our heroes. Every fall, a ceremony is held at the Firefighter's Memorial to honor the fallen firefighters lost during the year.

A replica of this monument was used during the filming of the funeral scene of the 1991 movie *Backdraft* starring Kurt Russell. The sequence was not shot at the cemetery, but Rosehill has been in the movies. The gunfight climax in the film *Next of Kin* with Patrick Swayze, released in 1989, was shot near the Gothic May Chapel, west of the pond.

The sculptor of both the "Our Heroes" and the Volunteer Firefighter Monuments, Leonard Wells Volk (1828–1895), is most famous for his castings of Abraham Lincoln's life mask and hands, as well as the Stephen Douglas tomb on the city's south side. Volk's last piece of commissioned work was a statue of himself under which he is buried at Rosehill. He looks comfortable seated in a relaxed pose as if lounging in a park on a Sunday afternoon. His hat tossed casually at his side, the image is detailed down to the buttons on his vest and his bony fingers resting gently on his cane.

By contrast, in the northeast corner of the cemetery lies the 6'6" remains of Chicago Mayor "Long John" Wentworth (1815–1888). He was a personal friend of Abraham Lincoln and helped carry his coffin to the courthouse when it stopped in Chicago. Mayor

Wentworth (1857–58, 1860–62) is credited with disbanding the volunteer fire department and pushing for the professional force after the fire on Lake Street in 1857 killed 23 people, including firefighters and civilians. The first steam pumper the CFD owned was affectionately called the "Long John" after this charismatic leader.

A flamboyant and egotistical mayor, Wentworth was larger than life with his huge frame and 300-pound stature. He demanded the largest monument at Rosehill and got it, erecting a 72-foot obelisk before his death at a cost of $36,000. His accomplishments as a statesman are boldly chiseled into the massive structure, the base alone weighing 50 tons. "Long John" is actually buried about 20 feet in front of his monument, under a small stone marker simply inscribed, "J.W."

Buried by the southern lakeshore of the central pond is former Fire Commissioner Albert W. Goodrich (1868–1938). He is credited with ordering the unique red and green lights that grace either side of Chicago firehouses and fire apparatus to this day. The Goodrich family is buried around a stately obelisk, each with their own individual, rectangular, stone marker.

Charles Gates Dawes (1865–1951) was vice president of the United States (1925–29), serving with Calvin Coolidge, and he shared the Nobel Peace Prize of 1925 for his plan to restore and stabilize Germany's economy after WW I. Dawes' classic mausoleum sits next to Rosehill's central pond, resembling a welcoming playhouse, complete with a front porch and two supporting pillars on either side. On occasion, a small American flag is seen in the iron gate securing the front door. During his administration, President Coolidge was responsible for instituting National Fire Prevention Week, which we observe annually.

Rosehill also contains the largest public mausoleum in the city near its western gate, housing one of the finest collections of Louis Tiffany stained glass in the world. Here, interred behind the elegant marble walls, are more captains of industry—Aaron Montgomery Ward, Richard Warren Sears, and John G. Shedd.

The mausoleum had a fire once, and it took four engines strung together with hose, pumping water from a hydrant outside the gates one to the next, to obtain enough water to extinguish the blaze. Just like Graceland, there are no fire hydrants on the cemetery grounds.

Graceland Cemetery is in 78's backyard, and Rosehill is a bit further north, but both share a link to the past, being established before the Great Chicago Fire and continuing to keep our important fire heritage alive for future generations to discover.

A firefighter stands guard atop the Firefighter Memorial as if surveying the cemetery.

Opposite:

Top Left: *Four old-style fire hydrants topped by weather-beaten helmets surround the fire memorial.*

Top Right: *Leonard Volk created the Volunteer Firefighter's Memorial, but his last commissioned piece of work was this realistic statue of himself, under which he is buried.*

Bottom Left: *The colorful Chicago mayor, 6'6" "Long John" Wentworth, has the tallest monument at Rosehill Cemetery at 72 feet. The base weighs 50 tons.*

Bottom Right: *Former V.P. of the U.S., Charles Gates Dawes rests in this Greek-style mausoleum. Note the American flag in the door.*

Held at Rosehill Cemetery annually is a ceremony for firefighters, active and retired, who died during the preceding year. Two boys enjoy the passing honor guard during the proceedings.

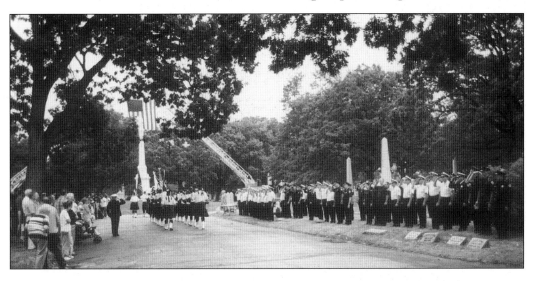

Firefighters stand at attention as the procession passes.

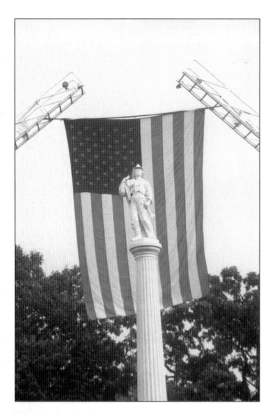

This is a close-up view of the Volunteer Firefighter's Memorial during the services.

The largest collection of Tiffany glass in the world is housed in Rosehill's Mausoleum, which inters such visionaries as Richard W. Sears, A. Montgomery Ward, and John G. Shedd.

*It is a spectacular view of the friendly confines from the roof of the firehouse, but unlike
neighboring rooftops, no one climbs up here on game days.*

CHAPTER 8

IN THE SHADOW OF
WRIGLEY FIELD

No book about the Wrigley Field firehouse would be complete without appreciating the history of famous Wrigley Field, located directly across Waveland Avenue. The two are inextricably linked forever, the firehouse literally sitting in the shadow of the grand ballpark.

As we know, Joseph Sheffield was the original founder of the Lake View area, naming the streets of "Sheffield" and "Waveland," but never realizing how they would one day become synonymous with baseball and the boundaries of the most famous ballpark of all time. By the 1840s, Sheffield was a successful businessman, and in the mid-1850s, he founded the Chicago, Rock Island, and Pacific Railroad. Trains were the way of the future, long before motorized vehicles became the norm. In 1874, another railway line was brought into the area—the Chicago, Milwaukee, St. Paul, and Pacific line extended southward from Milwaukee,

Wisconsin, through Lake View into the city. It was part of the Kingsbury Branch, originating at Goose Island, and it ran along Seminary Avenue, just west of where the ballpark and firehouse are today.

At the same time train traffic was taking off, a Lutheran minister named William Alfred Passavant (1821–1894) inherited a sandy grove of cottonwoods and ash trees where Wrigley Field stands today. Upon receiving this land at Clark and Addison, Passavant went right to work building St. Mark's Lutheran Church. In 1891, he opened the Theological Seminary of the Evangelical Lutheran Church with six students. One source reports that this is how Seminary Avenue received its name, since the street ran along the western border of the actual seminary.

As noise in the area escalated due to increasing commerce and more train activity, church officials feared quiet study at the seminary was becoming a thing of the past. So in 1910, they sold the property to Milwaukee investor Charles Havenor for $175,000. The seminary closed and moved to Maywood before ultimately ending up in Hyde Park. Havenor hoped to make his money by leasing the land to the railroad as a yard for switching their trains, but over the next couple of years, he sold it to Edmund Archambault, who purchased the prime real estate in pieces.

Meanwhile, across town at the West Side Grounds, the National League had won the World Series of 1908 against the Detroit Tigers. Baseball was becoming a popular national sport.

Investor Charles Weeghman came to Chicago in 1892 as a waiter, but he eventually made millions in the restaurant business. He wanted to get in on the popular sport sweeping the country but was unable to buy into the National League. Instead, the new Federal League was being formed so Weeghman, in partnership with fish distributor William Walker, bought the ChiFeds. He was made president of the club,

Here is a view of Wrigley Field's pass gate from inside the firehouse door.

Wrigley Field, built in 1914, is literally out the door and across Waveland Avenue from the firehouse, built in 1915, as shown here.

then went searching for a place to play ball. He found the area at Clark and Addison to be perfectly suited to build his new Federal League ballpark. On December 31, 1913, he leased the valuable property from Archambault for $16,000 per year for 99 years, on the condition that he build modern structures on the land and not spend more than $70,000 on improvements. Nobody knows if Weeghman intended to break the terms of the agreement, but he spent $250,000 to have Zachary Taylor Davis, the architect of the old Comiskey Park, to design and construct his fabulous ballpark.

Weeghman wanted a grand park, the best ever built, and he got his wish. Today, Wrigley is the oldest National League park still in use. Only the American League's Fenway Park in Boston is older. Both Fenway and Tiger Stadium in Detroit opened April 20, 1912, but the last game played at Tiger was on September 28, 1999. Fenway is also

scheduled for the wrecking ball, probably after the 2002 season, which will leave Wrigley as the last of the old parks in either league still being used for major league baseball.

For several years, the English Evangelical Lutheran Church of the Holy Trinity rented space from St. Mark's. In 1912, the two congregations merged and then a couple of years later were forced to move two blocks to the west to make way for the ballpark. Today, the Holy Trinity Lutheran Church is still located at 1218 West Addison.

On February 23, 1914, four seminary buildings were torn down, and the next week five hundred workers began constructing Weeghman Park. In one month, the structure was completed, opening April 23, 1914, for the Federal League ChiFeds to take on the Kansas City Packers.

Weeghman decided during that initial 1914 season to have a name-the-team

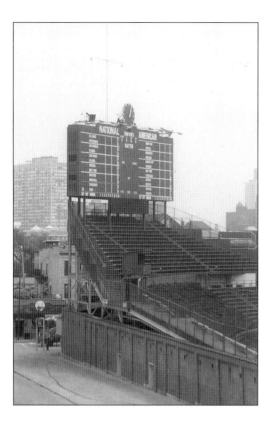

High over the intersection of Waveland and Sheffield sits the mechanical scoreboard of Wrigley Field, still operated by hand as it has been since 1937. The 10-foot clock was installed in 1941.

contest. After 350 entries were considered, the Whales was selected as the new team name, replacing the ChiFeds, but the Federal League was not going to last for long. It folded after only two years in operation, when the 1915 season was completed. However, Weeghman had already put his mark on the merchandising of baseball, establishing the first permanent concession stand at the park in 1914. As Weeghman scrambled to find another team, Engine 78's frame firehouse across the street was being razed and rebuilt in modern brick.

Since Weeghman was an owner in the Federal League, he had the first opportunity to buy controlling interest in a National League team. He put together a team of ten investors, including chewing gum magnate William Wrigley Jr. (1861–1932), and together they bought the National League Cubs for $500,000 from Charles Taft of Cincinnati, half brother of the former president of the United States. Weeghman was named president of the Cubs and immediately moved his new team from the West Side Grounds to his magnificent Weeghman Park, then folded the remaining Whales into the new franchise. The West Side Grounds at Polk and Lincoln (now Wolcott) were torn down after the Cubs moved out. The University of Illinois Medical Center occupies that site today.

On opening day at Weeghman Park on April 20, 1916, the Chicago Cubs beat the Cincinnati Reds 7–6 in 11 innings. From the beginning, Weeghman understood the value of publicity, having a bear cub attend that first game, then later in the season allowing fans to keep the foul balls rather than return them to the playing field. The idea came across loud and clear—it was fun to go to the ballpark.

The team not doing well, Weeghman was forced to sell off shares of his team for cash until William Wrigley owned all of his interest. When the Cubs went to the World Series in 1918, they lost to the Boston Red Sox, but it was the first time the "Star Spangled Banner" was played before a baseball game. Another baseball tradition was born at Wrigley Field. By 1919, William Wrigley owned controlling interest in the entire syndicate and became sole owner of the team.

Weeghman Park officially became known as Cubs Park in time for opening day of the 1920 season. It was the beginning of the modern era of baseball. In 1926, the park was renamed again, this time as Wrigley Field in honor of the team's owner, William Wrigley.

The 1930s saw innovations to Wrigley Field itself. Bill Veeck (1914–1987) became well-known in later years for goofy giveaways and large-scale publicity stunts he staged with the teams he owned, but he got his start at Wrigley.Field.

Bill's father, William Veeck Sr., was a

baseball writer when William Wrigley made him president of the Cubs. From the start, Bill worked for his dad around the park selling soda or admission tickets, or helping the grounds crew. As a young adult, he was often supposed to be at work early to slice hot dog buns or to perform some other task, but Bill liked to party and usually stayed out too late. To make his life easier, he arranged to stay at Engine 78's quarters across the street after he had been out most of the night. This way he was already close to the park and could report to work on time the next morning.

After Veeck's father died in 1933, he went on the job full-time for the Cubs, working his way up to the position of treasurer. Bill Veeck is responsible for the unique scoreboard and beautiful ivy that Wrigley Field sports today, both installed in 1937.

The manual scoreboard is 27-feet tall and 75-feet wide. Round eyelets flip over to display the batter at the plate and if a play was scored as a hit or an error. The number of runs scored is updated each half-inning by replacing a plywood board with the proper number painted on it. To determine the score at Wrigley, you must be able to add . . . there are no electronic totals here. No one has ever hit the scoreboard with a batted ball, although golfer Sam Sneed hit it with a golf ball teed off from home plate.

Philip Knight Wrigley (1894–1977) was the son of William Wrigley and owner of the Cubs after his dad died. He wanted an outdoor motif in keeping with the image of the "Beautiful Wrigley Field" he was trying to create. To fulfill this wish, eight Chinese Elm trees in pots were placed on the concrete steps behind the center-field bleachers. The brisk winds off Lake Michigan continued to blow the leaves off the trees, making it impossible to keep them alive. After several attempts, the idea was scrapped.

This view was taken inside beautiful Wrigley Field from the upper deck.

In this photograph, Dad puts out a hot dog stand on fire in Wrigley Field's right-field grandstand. The fire was so hot that it turned coinage in the vendor's cart a glowing red. The action was carried live on the television broadcast during the Cubs' baseball game against the San Francisco Giants on May 28, 1961. (Source unknown.)

Wrigley's famous ivy, however, has remained a ballpark fixture for more than 60 years. Veeck suggested that the ivy would be a nice addition to the outdoorsy atmosphere of the park, reminiscent of minor league Perry Stadium in Indianapolis, Indiana. Veeck planned to have the ivy planted during the off-season after the 1937 season, allowing it all winter to take root. His plans were thrown into a tailspin when he got the call from Phil Wrigley while out of town saying that he hoped the ivy looked great, because he was bringing visitors to see it during the last Cubs homestand of the season. In a panic, Veeck called a friend who owned a nursery for help, and they devised a plan. Portable lights were strung so workers could toil through the night while they planted 350 Japanese bittersweet and 200 Boston ivy seedlings. The bittersweet would give the much desired effect of ivy immediately, but the ivy would eventually take over as originally planned. The trick worked, and forever after Wrigley Field has been blessed with its picturesque ivy.

Another of Veeck's innovations was the addition of red and green lights mounted on a crossbar on top of the scoreboard to let passing "L" passengers know if the Cubs had won or lost that day. The green light meant a win, while the red denoted a loss. The concept evolved into a similar practice used today—flying a white flag with a blue "W" symbolizes a Cub victory to the outside world, while displaying a blue flag with a white "L" sadly signifies a Cubbie loss.

The enormous 10-foot clock was erected on top of the scoreboard in 1941. That same year, Wrigley was the first to introduce organ music at the game. This was just another tradition established at the friendly confines that continues to this day.

The Cubs have played in several World Series, but probably the most memorable appearance to Chicago fans is their last one in 1945. During this series, the infamous "Billy Goat Curse" was cast and has become the "reason" the Cubs have not been in the fall classic ever since. Game seven with Detroit was being played at Wrigley. William "Billygoat" Sianis, owner of the famous Billy Goat Tavern, brought his pet billy goat to the park, but Phil Wrigley refused to let the animal in the gate. In response, Sianis put a hex on the Cubs. They went on to lose the game 9–3, and thereby lost the Series. Many over the years have tried to remove the so-called curse by exorcisms and other rituals, but nothing has helped the doomed Cubs make it back to the Series.

One more great tradition at Wrigley came to an end when the Cubs played their first night game at home. For years, daytime baseball was the norm at Wrigley, but national television audiences demanded nighttime play. It is ironic that the Cubs were the last team in the majors to erect lights when they were already at the park waiting to be installed in 1941, but after the bombing of Pearl Harbor, they were donated to a shipyard to help the war effort.

On August 8, 1988, the lights were switched on for the game against the Philadelphia Phillies, but after 3 1/2 innings, a torrential downpour forced the game to be called, officially wiping it from the record books. This left some Cub fans to wonder if God preferred day baseball. The lights were actually used unofficially the night before, when an afternoon game went long. Finally, on August 9, the Cubs played the New York Mets under the lights for real and won 6–4.

It is true that Wrigley Field has a glorious baseball history, but football also made its mark long before the walls were covered with ivy. The Chicago Bears called Wrigley home for 50 seasons.

In 1920, George S. Halas went to work for A.E. Staley of the Staley Starch Works of Decatur, Illinois. As the new recreational director of the company, Halas was assigned the job of organizing a professional football team. He excelled coaching the Decatur Staleys, winning 13 games while losing only one that premiere year. His winning ways would continue throughout his career.

Due to financial problems with his company, A.E. Staley gave Halas $5,000, and allowed him to move the football team to Chicago as long as he kept the Staleys as the team name for at least one more year. George agreed, and the Chicago Staleys arranged to lease space at Cubs Park from Bill Veeck Sr., president of the Cubs baseball team. The Staleys won the 1921 Championship with a 9–1–1 record.

The next year, Halas changed the name of the team to the Chicago Bears, a natural choice since George loved baseball, playing professionally at one time with the New York Yankees. Now his football team was playing in Cubs Park, home of the Chicago Cubs.

Halas tried to retire as head coach three times over the first 30 years of his coaching career, but he always returned, bringing with him his championship attitude and immense love for the game. Before Don Shula of the Miami Dolphins broke his record in 1994, George Halas was the winningest football coach of all time, with 324 wins during his total 40 years of coaching. He was fittingly enshrined in the Football Hall of Fame in 1964.

In 1961, the Bears picked All-American Mike Ditka from the University of Pittsburgh as their first-round draft choice. Iron Mike continued his excellence, playing as an explosive tight end for the Bears. Known for his grit and determination on the gridiron, he won the coveted Rookie of the Year Award, blowing away his competition by amassing three times the votes received by quarterback Fran Tarkenton of the Minnesota Vikings during balloting by the Associated Press. He was the first tight end elected to the Football Hall of Fame in 1988, being inducted July 30, 1988, about a week before Wrigley Field had lights. No night football games were ever played at the friendly confines.

During Ditka's playing days at Wrigley, he often visited the firehouse, sitting around the kitchen table shooting the breeze with the firemen. Ditka says, "Hell, in those days, we hung out in gas stations and car washes, too." Fellow future Hall of Famer, Bill George was often his companion while they visited around the neighborhood.

Ditka fondly remembers "Papa Bear" George Halas and playing at Wrigley Field. Halas loved Chicago and its fans. Ditka muses that if it were up to him, could he have done things as well as his mentor, Halas? George transformed the Chicago Bears and the NFL into an institution.

One time while playing at Wrigley, a fan mouthed off to Ditka. He responded by saying something "that wasn't very nice." Halas pulled Ditka aside and told him he shouldn't talk to the fans that way, but when the same fan got cocky with Halas, he told him to "go screw himself." Halas was his own man.

Halas loved Chicago, but it is doubtful if Chicagoans truly realized it. His heart was in the right place, even if it didn't seem to show most of the time. George was always trying to make a buck, too. He would sell "limited vision" seats positioned up high, behind a support beam. They were awful, but he would manage to get $5 apiece for them. Ditka is often quoted as saying that Halas "threw nickels around like manhole covers," but he insists that this comment was always meant in jest. George was really a great guy, and one to be admired.

For five months of the year, Wrigley Field was home to the Bears. The locker rooms were not as nice then as they are now, and often lurking behind the lockers you would find some guy trying to sell a stolen shotgun or sport coat. It went with the territory. With love and respect in his voice, Ditka says that Wrigley Field was a great place to play football, and Halas was a great coach to play for. He says, "When you see Wrigley Field or Soldier Field, you always know you're in Chicago. They are distinctive landmarks. Most of the modern stadiums today all look alike, making it hard to tell which city you are even in."

Not only did Ditka visit the firehouse, so

Engine 78 is shown here parked under the most recognized marquee in baseball, the home of the Chicago Cubs.

did Mr. Halas. He would stop by and give Captain Jones a standing-room-only pass for the upcoming Bears season. The firehouse and firemen of Engine 78 played an integral part during football season. A firm that put up temporary bleachers in right-center field in Wrigley Field before the season began hired off-duty firemen. In 12 ten-hour days, the bleachers would be up. The guys from E78 and the neighboring firehouses, such as E55 and T44, would be invited to work. They all worked hard, but nobody wanted to do the job with Firefighter Eddie Krey, as he was known for his hustle, usually exhausting his partner as they placed long, heavy 2-by-12's onto the framework of the bleachers.

In those days, the Bears played twelve games per season, six of them at home at Wrigley Field. It always worked out that two of each of the home games fell on each shift. This made the firehouse a focal point during these games. Anxious to make a quick bathroom stop, the patrons from the ball game would come into the firehouse at half time to use their rest room instead of waiting in line at the ballpark. The line went from the bathroom doorway in the back by the kitchen, through the apparatus floor, and out the front door. A pot of hot coffee would be set up in the kitchen with a can for tips alongside. A sign simply read, "Hot Coffee. Thank You." No price was ever posted, but after a typical game, $50 to $60 was usually in the can. This would pay for meals for the shift over the next couple of days.

During the Bears' last championship game played at Wrigley Field on December 29, 1963, against the NY Giants, the firehouse basement was used as a press photographer's darkroom. The game time temperature was 9 degrees at kickoff, conditions favoring a defensive team like the Bears. Their job was to stop the strength of the Giants, their offense. During the game, the Bears intercepted five passes from quarterback Y.A. Tittle and went on to beat the Giants 14–10, before 45,801 fans jammed into frigid Wrigley Field.

During half-time, photographers from the various newspapers ran over to the firehouse basement to develop and fax their first-half pictures of the game to their publications, some as far away as California. The press corps was only there a few hours, but treated the firemen wonderfully. They brought in all kinds of catered food, inviting the guys to join them, then later had the house pool table fixed after they had used it to hold their materials. The tournament-size pool table was never in great condition, chipped in several places, but the photographers insisted on having it restored for the firehouse as a way of saying thank you for the gracious use of their basement.

The Bears played their final game at Wrigley Field with a flourish on December 13, 1970, trouncing the Green Bay Packers 35–17. The Bears left Wrigley Field with a record of 221–89–22. No other team in NFL history has had the same home field for as long as the Bears. This 332-game record still stands today. After 50 seasons at the beautiful, homey ballpark, the Bears moved to Soldier Field across town in time to start their 1971 season and have resided there ever since.

Sadly, only baseball is played at Wrigley Field these days, but regardless of whether the Cubs win or lose, Engine 78's firehouse is always a hub of activity. It is *the* meeting place for fans. The solitary red bench perched quietly outside has been the resting place for more than one mother, while her kids chase ballplayers looking for autographs after a game. The fire hydrant on the side of the ramp is usually open during the games to provide refreshment on a hot summer day in Chicago. Wrigley Field's pass gate is located directly across Waveland, admitting patrons, while vendors can be heard hawking their wares just down the street. On game day, the area takes on a festive atmosphere.

Many celebrities over the years have been known to frequent the friendly confines, but occasionally one will be seen milling around outside as well. My dad tells the story of getting a run, but the engine could not get

out due to a man standing in the way on the ramp. He gently asked the large man to step aside. Not realizing where he was, he immediately complied, moving to the side. It turned out that he was Forest Tucker, star of the old "F-Troop" television series.

I remember visiting the firehouse with my family as a little girl before attending a baseball game. It was during these trips that my firehouse memories were made. Dad allowed me to sit on the engine's bumper and pull the string, ringing the heavy metal bell. Ding! Ding! The sound was simple, but it delighted this eight-year-old. I climbed up into the smoky-smelling cab of the rig and sat wide-eyed, marveling at all the gadgets and controls. The engine looked immense to me. I was told that I could push a button on the dashboard, and to my delight and surprise, the siren would shriek causing me to giggle and smile broadly. The firehouse was magic, and I appreciated every chance I got to escape into their secret world, even if only for a short while. Later, at the game, we would sit where I could see the firehouse, in the left-field corner against the wall. If I heard sirens, I was up in a flash, peering over the wall to wave to my heroes riding the back step of the engine as they hurried down Waveland with their lights flashing. This is the essence of wonderful childhood memories.

For those of you who are wondering if there have ever been any fires at Wrigley Field, the answer is yes! On Sunday, May 28, 1961, the Cubs took on the San Francisco Giants. In those days, hot dog carts were wheeled through the stands. Each had its own source of gas in which to cook the wieners. During the sixth inning of the game, one of these carts in the right-field grandstand started burning wildly, with large flames and a lot of smoke. Engine 78 was called to the scene to extinguish the blaze. Dad was on the hand pump, but unfortunately it was not containing the fire. The phrase "when in doubt, lead out" came to mind, so they dropped a line bringing it

into the ballpark, while Engineer John Burek sent the water. The flames were being fed by the gas supply in the hot dog cart. Using the water to protect him, Firefighter Gus Aparo reached in and through the fire to shut off the fuel supply. Dad extinguished the blaze to the cheers of 20,000 fans! The fire was so hot that the change the vendor had left on top of the cart had turned red-hot due to the intensity of the blaze. While this episode was unfolding, WGN-TV was televising it as part of their normal baseball game broadcast. Imagine my mom at home, peacefully doing her ironing while watching the Cubs game, when she saw my dad on TV putting out the hot dog stand! The next day's newspaper carried a picture of Dad in perfect silhouette, while the cart was still fully involved working the line on the fire. The caption read, "Hot Time at Wrigley Field." The heat didn't spark a win though—the Cubs lost to the Giants 6–5.

The men at Engine 78 are not just firemen, most are Cub fans, too. Back in the 1960s, when the stands weren't crowded, the guys would occasionally wander over to the park to catch a few late innings of the game. Their loyal mutt, Pat, was always with them and was allowed in the park with the boys, no questions asked. The firemen were always welcome and so was Pat. If a run came in while they were in the ballpark, Pat was still the first one on the engine and rode it like a surfboard all the way to their call.

During the excitement of the 1984 season, 78's firemen also caught Cubs Fever. The firehouse sported a banner over its doorway proclaiming, in Cubbie blue, "Official Firehouse of the 1984 World Series." Pictures of the World-Series firehouse appeared in several newspapers. T-shirts picturing the decked-out firehouse were also produced, mostly as novelties for the firemen and their families. Unfortunately, the beleaguered Cubs never made it to the Series, losing to the San Diego Padres in a five-game playoff series, after winning the first two games. The Cubs were exasperating to watch.

In the 1980s and early 1990s, Wrigley Field seemed to be the place to make movies. In *The Blues Brothers*, made in 1980, the famous red and white Wrigley Field marquee appears in the background of a scene, as the Nazi bad guys ponder the fake, illegally-obtained address for Elwood Blues, 1060 West Addison Street. That's Wrigley Field.

Many more movies have been filmed inside the friendly confines, including the 1986 truancy movie *Ferris Bueller's Day Off*. Ferris plays hooky from high school for the day and goes to a Cubs game, just like kids throughout Chicago have been doing for years.

Wrigley Field, from its early days as Weeghman Park to the present, has always been a neighborhood ballpark showcasing how baseball was meant to be played. Stepping out of the concrete bowels of the park into the warm sunshine and gazing on that emerald field for the first time takes your breath away. The times have changed, but one thing is still certain, hearing sirens during a Cubs game means either Engine 78 or Ambulance 6 is going out on a run. The boys in blue on the other side of Waveland, in the shadow of Wrigley Field, continue to protect the Lake View neighborhood from fire and disaster, as they have since 1884.

Gloria Swanson, the silent movie diva, was born only a half-block east of the firehouse at Waveland and Kenmore.

CHAPTER 9

FAMOUS NEIGHBORS
AND LANDMARKS

The Wrigleyville area is comprised of much more than just Wrigley Field and the firehouse. It is filled with history from one end to the other, many places with Chicago Landmark status.

On the northeast corner of Waveland and Kenmore, just down the block from the firehouse, sits a house some refer to as the "Budweiser Building" because of the white letters painted on the red roof advertising the popular beer. Here, silent screen actress Gloria Swanson was born on March 27, 1899, on the second floor. In her autobiography, she gives her birth address as 341 Grace Street. Even before the street renumbering in 1908, this address never existed. Her birth

Essanay Studios, a Chicago Landmark, is where Gloria Swanson was discovered. "S&A" mimics the names of its founders: George Spoor and Billy Anderson.

certificate, filed 27 years after her actual birth, lists her residence as "Waveland and Grace." Both streets run parallel to each other in an east-west direction and do not intersect. The documented addresses may be vague, but the picture of her house in her book clearly shows the two-story building with the gabled tower-like roof. The firemen of Engine 78 have passed this knowledge down to successive generations.

The house faces Kenmore, a one-way street running south ending at Waveland, just outside Wrigley Field's left-field wall, then resuming at Roscoe further to the south. When a home-run ball leaves the friendly confines over the left-field fence and bounces up Kenmore, it is heading the wrong way up a one-way street! By contrast, fire equipment always travels the correct direction on a one-way street. If Engine 78 got a run in that block (3700 N) of Kenmore, they would either back down the street from Waveland, or go around the block and come in from the north, since the truck company following them would be close behind.

Swanson was "discovered" in 1913, when she and her aunt visited nearby Essanay Studios, a couple miles to the north of her home, to see how movies were made. The silent screen diva is best known for her disturbing portrayal of the washed-up silent movie screen star, Norma Desmond, in *Sunset Boulevard* in 1950. Swanson will always be remembered for her famous line as the aging Ms. Desmond, "I'm still big; it's the pictures that got small." Essanay Studios, where Gloria was discovered, is a play on words—"S&A" mimicking the initials of the co-founders, George Spoor and Billy Anderson.

During the early days of movie making, Billy Anderson was arrested for turning in a false fire alarm, just so he could film the walrus-mustached actor Ben Turpin being chased by the horse-drawn fire wagons.

In May of 1921, the grounds temporarily housed Engine 83, while their new quarters were being built, just as Engine 78 once used

Alta Vista Terrace is located one block north of the firehouse between Grace and Byron. This block-long street is modeled after Maypole Street in London and was built by developer Samuel Eberly Gross in the early 1900s. Each rowhouse matches its diagonal opposite.

the Mandel Brothers Garage. The Essanay building still stands and was designated a Chicago Landmark on March 26, 1996. Colorful terra-cotta Indianheads, the Essanay trademark, still grace either side of the entrance to the structure, with shiny gold letters spelling "Essanay" above the painted white doorway. A plaque hangs to the right of the entrance, proclaiming the official city designation.

Chicago's Landmark status means the property has significant historic and cultural value to the neighborhood. This status can only be granted by the Chicago City Council on the recommendation of the Commission on Chicago Landmarks.

We have already discussed several locations given Chicago Landmark status, such as the Getty Tomb in Graceland Cemetery. The facade at Rosehill Cemetery

and Chicago's beloved Water Tower also have this special designation, saving them from the possibility of the wrecking ball one day.

Districts can also be designated as Landmark areas. Such is the case with Alta Vista Terrace, at 3800 North, about a block north of the firehouse. On September 15, 1971, it became the first district to be given Chicago Landmark status, and it is also listed on the National Register of Historic Places. Alta Vista is a narrow, one-way street running south, and means "high point" or "high view" in Spanish. Developer Samuel Eberly Gross bought the block of land bordered by Seminary, Byron, Kenmore, and Grace. Instead of building around the block of property, he sandwiched Alta Vista Terrace through the middle of the plot, turning the houses inward toward each other, creating a cozy neighborhood all to itself.

111

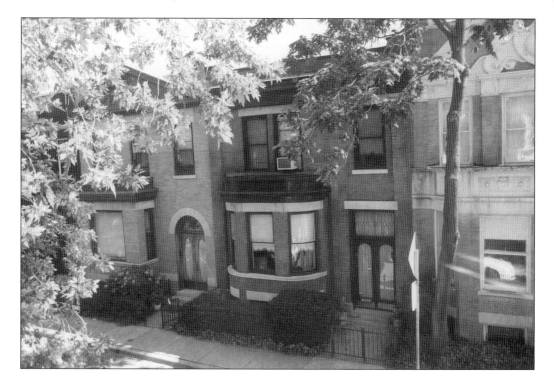

Alta Vista Terrace became the first district to receive Chicago Landmark status in 1971. Here is a close-up view of some of the lovely structural details of the homes.

The Victorian homes were built between 1900 and 1904, and were designed to resemble Maypole Street in London. The street has the feeling of an old English novel, a place time forgot, and is known as the "Street of Forty Doors," because 20 row houses line each side of the street, side by side. This makes firefighting difficult, as there are no "gang-ways," or walkways, between the buildings in which to get around the structure. A fire company would either have to go through the house next door to get to the rear of the building, or send another company around the back. The style of each home matches its counterpart across the street from it diagonally. In other words, the townhouse at the southwest corner of the block matches in style the structure at the northeast corner, with only minor variations as to brick color and other small details. Each house is a two-story, six-

room residence, except for the four three-story, nine-room townhouses in the center of the block. When these were built, each type was identical on the inside with high ceilings, oak floors, and the same entranceways. From the outside, variations can be seen in the color of the Roman brick, the fancy roof detail, the design of the frosted glass doors, and the beautiful detailing of many stained-glass windows. Over time, some of this has changed, but for the most part, these buildings have remained the same, including their original earth-toned exteriors. Due to their Landmark status, any structural changes must be approved by the Commission on Chicago Landmarks to keep the integrity of the area intact.

To the north, at 640 West Irving Park Road and 4030 North Marine Drive, sits the former Immaculatta High School and its convent buildings. The architect, Barry Byrne, was a

student of Frank Lloyd Wright and designed the Gothic-detailed high school in 1922. Lake Michigan was much higher in those days and used to lap up near the school's back door. The convent was added in 1954–55, with an addition to the school occurring the next year. What is unusual is that Byrne also designed these subsequent additions. Operated by the Sisters of Charity of the Blessed Virgin Mary, this classic building with its high ceilings and tall, skinny windows topped with elegant arches was placed on the National Register of Historic Places in 1977. It was given the Chicago Landmark designation on July 27, 1983.

In the late 1950s, when Engine 78 passed by on a run, if the girls were outside then the sisters would make them kneel on the sidewalk, cross themselves, and pray for the firemen and any victims of the incident. As late as 1977, Sister Joan Newhart, sister of Chicago comedian Bob Newhart, taught science at this all-girl school.

A few blocks to the west, on the southeast corner of Clarendon and Irving, a two-story weather-beaten frame house once stood, the dwelling of former speakeasy owner, James Probasco. Here, in May of 1934, the notorious bank robber, John Dillinger, had cosmetic surgery in an attempt to disguise his facial features and alter his fingerprints. For a fee of $5,000, Dr. Wilhelm Loeser, known as a "magician with the knife," removed three moles, filled in the dimple on his chin and the depression on his nose, and removed a scar from above his lip. Five days later, Dillinger's fingerprints were removed and adjustments were made to his facial surgery. He stayed here about a week to recuperate, then he was on the move again but returned to Chicago before long.

On June 22, 1934, Dillinger's 31st birthday,

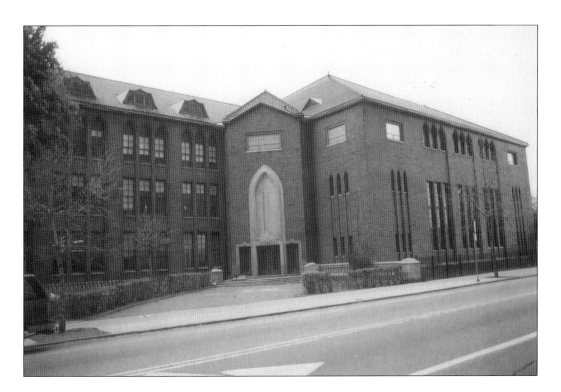

The former Immaculatta High School also has Chicago Landmark status, but the building now belongs to the American Islamic College.

J. Edgar Hoover named him Public Enemy Number One. This handsome and daring bank robber had become like a Robin Hood character to the public, often opting to leave patrons present alone while he was robbing a bank. When word of him jumping over a bank railing was released, women swooned over the good-looking swashbuckler. He lived unnoticed on Chicago's north side, often frequenting the Seminary Restaurant at the corner of Lincoln and Fullerton and visiting Wrigley Field on occasion.

His demise came at the Biograph Theater on the night of July 22, 1934. Dillinger, his girlfriend, waitress Polly Hamilton, and their landlady Anna Sage took in the movie *Manhattan Melodrama*, starring William Powell and Clark Gable. Sage became immortalized as the "Lady in Red," her orange skirt appearing red under the marquee lighting. An illegal alien, Sage hoped that by identifying Dillinger for the FBI, they would help her avoid deportation to Romania. Unfortunately, her fears were realized, and she was deported anyway.

The Biograph, located at 2433 North Lincoln Avenue, is in Truck 44's still district. My grandfather was working at the firehouse that fateful night. According to him, when Dillinger emerged from the show, he headed toward the alley to take his usual shortcut from Lincoln Avenue to Halsted Street. As he stepped off the curb, an FBI agent whose brother had been killed by Dillinger, stepped up behind him putting a .45 to the back of his head and pulled the trigger. He had a personal score to settle and wanted to be the one to do it. Dillinger fell dead on the spot, the agent stepped back, and the rest of the FBI team opened fire, all taking their shots with machine guns, splattering bullets everywhere.

Dillinger was so well liked by the public that when news of his death spread, women rushed to the scene, tearing off pieces of their underskirts or offering handkerchiefs, asking the neighborhood kids to soak up some of his blood for their macabre souvenir. So many people used pocket knives to dig the spent slugs out of the telephone pole that it had to be replaced.

Today, the Biograph is a tourist attraction and still a fully operational theater. The old ticket booth has a female mannequin sitting in her chair, just as a real person would have been stationed more than 60 years ago. Old newspaper clippings describing the Dillinger incident are pasted to the windows of the ticket booth, reminding passersby of the history played out right there that hot July evening in 1934. A brass plaque affixed to the building reads, "This property has been placed on the National Register of Historic Places by the United States Department of the Interior." The love affair with Dillinger has continued through the years, and his ghost is still rumored to haunt the alley where he died.

The Wrigleyville neighborhood is more than just landmarks and famous personalities. It has a character all its own.

The Chicago, Milwaukee, St. Paul, and Pacific Railway mentioned earlier used to run immediately to the west of the ballpark. The tracks went north over Waveland and past the firehouse, parallel to Seminary Avenue. At one time, crossing gates were present across Waveland, whereas today, there is no hint that they ever existed. The first train on these tracks ran through the town of Lake View on May 1, 1885, from Larabee Street and Chicago Avenue on the south side, to Calvary Cemetery in Evanston on the north. One train ran south in the morning and returned northward at night. Residents settled along the route, substantially increasing property values. Long before motorized vehicles became the norm, trains were used to transport everything from people to freight. This was especially true for the pickup and delivery of coal.

On July 7, 1920, Collins and Wiese Coal Co. opened their doors at 3637 North Clark Street. It was located on the southeast corner of Clark and Waveland, immediately to the west of Wrigley Field. The railroad

Here is the author, posing as the famous "Lady in Red," outside the historic Biograph Theater, where John Dillinger, notorious bank robber of the '30s, met his bitter end. (Photograph by Peggy Pannke.)

tracks ran between these two giants, delivering loads of coal to the coal yard, and probably delivering other goods to the ballpark as well.

My dad vividly remembers the coal yard. A fire started once in the electronics of the operator's cab on the crane perched 150 feet in the air. Someone had to go up there and put out the fire. Being the young, strong guy on the company, Dad was elected for the job. Using a spanner, he slung a heavy, filled hand pump over his right shoulder. A spanner is a 48-inch strap with a 4-inch ring at one end and a spanner wrench at the other, used for tightening hose butts. It is an extremely useful firefighting tool. With the hand pump properly positioned, he carefully climbed the skinny metal ladder, taking one step at a time until he reached the fire. There on top of the little house-like structure, teetering in space, he extinguished the blaze.

Collins and Wiese closed their doors November 14, 1967, eventually being replaced on that corner by Henry's Hamburgers. Today, a small fast-food establishment and a car wash operate at this popular location, with no visible evidence left of the once mighty coal operation.

It may be hard to imagine, but coal companies were very prevalent in the Chicago area before the switch to gas for heating and cooking. Fires at these companies produced extremely hazardous conditions. On April 16, 1958, a 3–11 blaze at an abandoned coal yard at 1314 West Wolfram was so intense that the heat blistered paint on nearby houses and parked cars.

Known to locals as Dillinger's Alley, this small thoroughfare is used by residents to quickly cut between Lincoln Avenue and Halsted Street. Dillinger was shot as he stepped off the curb into the alley. My grandfather said that so many slugs fired by the FBI were dug out of the telephone pole by souvenir hunters that it had to be replaced.

Further north, out of 78's still district, the famous Lake View High School still operates at 4015 North Ashland Avenue. It originally opened on May 4, 1874, with 73 students. On Friday, March 13, 1895, it burnt to the ground but was rebuilt on a larger scale in 1898. It was the first public school built in the Tudor style and has had similar additions in 1916 and again in 1939. This impressive castle-like structure comprises an entire city block.

As with any school, fire drills are conducted regularly. One thing that Dad used to do as an officer was to block an exit to see how the kids would react. He would place a city sawhorse in a stairwell and then would stand in front of it as the alarm sounded, telling the kids that "he was the fire," and they could not continue out that way. The kids tended to freeze, and the teachers all were a bit rattled. Many exits would probably not be accessible under real fire conditions. Without real fire education, a tragedy could easily occur, and a routine drill would not teach them what they needed to know. Teachers are also supposed to close their classroom doors when leaving for a fire drill, cutting off the fire exposure. After the drill, firemen would go from room to room, noting which doors were left open. Those teachers were later reprimanded for their carelessness.

As with any school, fire drills are conducted regularly. During one such drill, Dad went into the office to inform the staff that they were there and ready to proceed. A white-haired boy was sitting, looking dejected, in the principal's office. Dad asked him, "You in a jam?" The kid solemnly nodded. Dad told him he used to spend a lot of time in the principal's office, too, but to look at him now—he was a captain on the fire department! The boy immediately sat up with a wide smile on his face, and the office assistant snapped, "Don't tell him that!" Dad retorted, "Why not? It's the truth!"

Besides places of learning, the Lake View area is also filled with recreation. At Waveland, next to the lake, lies the Sydney R. Marovitz Golf Course at 3600 North Lake Shore Drive. Founded in 1934 and designed by E.B. Dearie, this tricky, nine-hole course is known to locals as the Waveland Golf Course because of its location. Each hole is modeled after a challenging hole of various golf courses around the country. It is reminiscent of Pebble Beach Golf Course in California, with water flanking its eastern edge. Bunkers and water hazards come into play on this green, pastoral setting nestled quietly inside the hustle of urban Wrigleyville.

Immediately to the south of the golf

course sits the English Gothic-styled Waveland Fieldhouse and Wolford Memorial Tower. The structures were designed by Edwin H. Clark, architect of the Brookfield Zoo.

The 75-foot clock tower was built for $78,000 as a memorial to Jacob A. Wolford, a 40-year member of the Chicago Board of Trade. Wolford and his wife, Annie, lived on Chicago's swanky Gold Coast and often vacationed in New England. As Jacob grew older, his eyesight began to fail, limiting the activities he and his wife could participate in together. Something they did continue to enjoy were the daily bell concerts performed by local residents in Stockbridge, Massachusetts, located in the Berkshire Mountains near Boston. There, even though Wolford's eyesight continued to grow worse, the pair could still enjoy listening to the mellow, soothing tones of the chimes together. Jacob died in Chicago in 1917, his wife following nine years later. In her will, she left $50,000 to construct a bell tower reminiscent of the one she and her husband enjoyed together in Massachusetts. More money was added by the park commission, and the seven-story tower was constructed in 1931, in brown and off-white brick, complete with working clocks on all four sides.

From the clocktower's seven-story roof vantage point, Wrigley Field's third-base grandstand can easily be seen, and on a clear night, the faint lights of towns on the Michigan shore across the lake are within view.

Further south, along the lake shore near Belmont Avenue, stands the Haidan Indian Totem Pole. The original was donated to Chicago on June 20, 1929, by James L. Kraft, the food magnate, but was given back to the Indians in 1985. This replica, known as Kwanusila, is named for the carved thunderbird on top and was carved in British Columbia in red cedar like the original. It was dedicated to the school children of Chicago on May 21, 1986.

The beautiful Belmont Harbor lies directly

to the south of the totem pole, another popular recreation spot for the citizens of Chicago. Engine 78 provides fire protection here as well, but it begs the question, what can burn in a harbor surrounded by water?

On August 7, 1957, a converted World War II PT-boat made entirely of wood started burning inside its hull. It was necessary to get inside the boat to extinguish the blaze. An ax was used to cut the chain on a bunch of park district rowboats. The firemen climbed in, heavy with gear, the top edge precariously close to the water line, and inches away from their own disaster. They carefully rowed to the burning craft, carrying hoses hooked up from shore with them. Dad led the charge into the hull, but his water stopped. Unbeknownst to him, his line had broken. The newspaper picture the next day

The Wolford Clock Tower, erected in 1931, was built to resemble a belltower in Massachusetts.

The lovely Belmont Harbor serves some of the city's recreational boating needs.

clearly showed bubbles on the water's surface where the hose underneath had burst. The guys had to back out, get another line and do it again, but the next time they were successful at extinguishing the fire.

Located not far from Belmont Harbor is one of the more unusual structures in the area, the Elks National Memorial Building. Located at 2750 North Lakeview Avenue, it was built between 1923–26, and was originally dedicated to fallen Elks of World War I, but it has subsequently been rededicated to include heroes from other wars as well. The large round building is impressive, flanked on the outside by two life-sized bronze Elks. Two more large bronze sculptures nestle in their own niches on the front of the edifice. Inside, this public building boasts the large, ornate Memorial Rotunda with spectacular murals and multi-colored marble mosaic designs. This unique structure stands unnoticed, tucked away in residential Lake View.

Chicago has long been known for its culture and appreciation of the arts, especially theater. The Lake View area of the city is no exception.

One opulent movie house is the Music Box Theatre at 3733 North Southport Avenue. Opening August 22, 1929, it was a typical "movie palace" of its day, only on a much smaller scale. It is rich in elaborate detail, including the night-sky ceiling, giving the feeling of being in a balmy open-air garden while viewing a film. At one time, the fireproof curtain was tested by fire inspectors by actually holding a lit match to the curtain to ensure that it was up to code.

Gloria Swanson struggled with the internal pressures of stardom. John Dillinger struggled with external changes to his appearance. The Bears struggled with the NY Giants, and the Cubs struggled with the NY Mets. Through it all, for 85 years, the firehouse has always been there—a constant, stable symbol in an often-changing community. I was taught as a child that if I was ever in trouble to go to a firehouse. The firemen would help me as they have helped generations of Chicagoans. The members of Engine 78 and Ambulance 6 are just one fine example of the city's "can-do" spirit, and an integral part of the proud Chicago Fire Department.

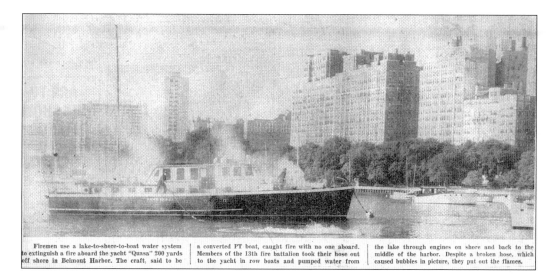

Firemen use a lake-to-shore-to-boat water system to extinguish a fire aboard the yacht "Quasa" 200 yards off shore in Belmont Harbor. The craft, said to be a converted PT boat, caught fire with no one aboard. Members of the 13th fire battalion took their hose out to the yacht in row boats and pumped water from the lake through engines on shore and back to the middle of the harbor. Despite a broken hose, which caused bubbles in picture, they put out the flames.

On August 7, 1957, a converted World War II PT-boat caught fire while anchored at Belmont Harbor. While Dad and other members of Engine 78 were in the hull of the boat, their line burst, as evidenced by the bubbles in the picture. They had to row back to shore for another line, using a Chicago Park District rowboat. (Source unknown.)

The Elks National Memorial Building at Diversey Parkway and Lakeview Avenue is created in an unexpected circular shape, with two life-sized bronze elks flanking the entrance.

Pictured here is the author, relaxing outside Engine 78's quarters. (Photograph by Marc Patricelli, FF, Engine 78.)

Here is the author with her father, posing at Engine 4's quarters and showing how proud she is to be a firefighter's daughter. Dad retired from this house in 1986, at the rank of captain, after 30 years of dedicated service to the Chicago Fire Department.

CHAPTER 10

AN AMERICAN FAMILY

Firemen are human. They worry and care about their families like anyone else, and their families are concerned about them, too.

Throughout this tale, you have heard harrowing stories of the day-to-day life of a firefighter. Think for a moment about the other side of the coin. While Dad was at work, we at home had no idea what kind of situations he was encountering. We worried! My mom deserves credit as the silent hero always holding us together. If she was concerned, I never knew it.

When Dad went to work in the morning, Mom went into action. She cleaned, took care of the house, and life went on regardless of what happened. She was always there, working in the background, but it was also her day to loaf a bit, too. Since she always made big meals for us when Dad was home, we enjoyed "cheating" while he was at the firehouse, sometimes having hot dogs, macaroni and cheese, or my favorite, pancakes for dinner.

When Dad came home the next morning, Mom was ready for anything. Sometimes they headed off to Sears or started on much-needed lawn work. Whatever the project, Mom was always by Dad's side. If he was late coming home, it was due to one of two things. He either caught a fire, or he stopped at the bakery—a vice he still indulges. We always knew when he had just come from a fire. He was tired, cranky, and smelled like a chimney. While he took a shower and got cleaned up, Mom made him a big breakfast of three eggs, bacon, and toast. After satisfying his hunger, he headed off to bed to sleep for hours. Woe to the person who dared make noise. The neighborhood kids could not understand why "Mr. Kruse was often crabby" until he took one of the kids to the firehouse to spend the night. Engine 78 caught 22 runs that particular day. Davey never caused any more trouble, sleeping the whole next day himself—exhausted, but educated by his firehouse trip.

Another job a firefighter's wife has is that of washing smoky fire clothes. Their work clothes don't get sent out to a service. . . their wives clean them. Mom always had Dad's cleaned and pressed, ready to go for his next shift, including washing the sheets for his bed. The CFD does not pay for maid service. She used to complain that getting the smoke ring out of his collar on the white officer's shirt was much harder than it was on the firefighter blues. After repeated scrubbings with an old toothbrush, the collars would begin to shred. You haven't seen ring around the collar until you've tried to clean a firefighter's shirt. My duty was to polish Dad's shoes for inspection. We all proudly did our parts.

Besides material support, we provided much needed emotional support as well. Mom says she was always "concerned" while Dad was at the firehouse. If she knew he was at a big fire, she worried more. Her concern showed when he got called in during the '67 Snow, not knowing when he'd be back. The Martin Luther King Jr. Riots of '68 were of particular concern to us, because this was more than fighting hazardous fires. These were angry looters with firearms and no respect for authority. These people were armed and dangerous. I became scared when the call came in for Dad to report to duty to the dangerous west side after King's assassination. Relief is the only word to describe what we felt when we saw Dad pull in the driveway after those tension-filled days. We rushed to his side with tears in our eyes, just happy to see him again.

Besides normal firefighting hazards, there were medical conditions as well. Dad was hospitalized due to a rupture several times, and he was once taken from the firehouse, directly to the hospital, due to a kidney stone. The joke was that it was due to bad seeds in a banana creme pie he had made that night for dinner. The boys even made up a nice certificate to commemorate this event. There is always concern whenever someone is in the hospital, but his fellow firefighters helped to ease our worries about Dad and

his worries about us. Firemen were there to chauffeur Mom to and from the hospital to visit him, and they were always available if we needed anything. The fire department is truly a caring family.

It is obvious that we were often concerned for Dad's safety, running in and out of burning buildings, but what about him? Was he ever scared? The public sees firefighters as the heroes they are rushing into fires, but inside they are made of flesh and blood and have human feelings of their own.

While Dad was at drill school, he was subjected to heights. A "pompier" ladder has one central rail with rungs attached to it crosswise. Climbing it takes considerable skill. A large, wide, hook-like top allows it to be placed through a window and attached on the inside under the windowsill. By using a series of pompier ladders, a building can be scaled, one floor at a time, placing successive ladders up to the story above. During training, firemen are required to climb up the pompier ladder, hook themselves to it, then lean backward out into space as a way to overcome the fear of heights. This same demonstration was always a popular stunt at the CFD Thrill Shows. Interestingly enough, pompier is the French word for firefighter.

Dad said that he handled the pompier ladder training without a problem; however, fighting a fire on the nineteenth floor of a building under construction was another story. The building had no walls or top on it. It consisted of open floors and massive steel girders. The stairs were also open with no railings. The plywood used for construction caught on fire on the eighteenth and nineteenth floors. By the time water filled the new standpipe in the building, the fire got away from them, so a snorkel was brought in with its powerful water stream. Water was poured on the fire, but since it was winter, this caused everything to turn to treacherous ice. Before long, 8–10 inches of the thick, slippery stuff covered the stairs, making it easy to slide off the open edge to the ground far below. The heartiest of souls

The author in full "turn-out" gear. (Photograph by Marc Patricelli, FF, Engine 78.)

would be tried under these conditions. With no leverage and working very carefully, they extinguished the fire and cautiously navigated their way back safely to earth.

The only time that Dad claims he was actually afraid, he was on the ground, and it wasn't even at a fire. He was assigned to the ambulance that particular day and got a run to the Howard Street CTA yard, where the train cars for that line were stored between use. The entire yard had electrified third rails running through it to provide power for the trains. The motorman had broken his hip and needed to be carried out of there. Dad and Frank Chambers precariously made their way over the lethal rails to the far corner of the yard. With them, they carried a metal stretcher. One false move, either by tripping on a rail or dropping the stretcher, and they

would both be electrocuted. Once the injured man was safely on the stretcher, three of the other workers offered to help carry their guy out with Dad. Swiftly, they headed for the ambulance, the experienced rail guys literally pulling Dad over the dangerous third rails. Dad, trying to adjust his gait, was terrified he would trip over one of the electrified rails and fry them all. After what seemed like an eternity, they finally made it safely out of the yard.

Not every call elicits fear. Sometimes, the sights along the way are downright humorous. Like the hot, sunny, summer morning around 5 a.m. when E78 got a run to follow on E83's box. Engine 78 was heading north when there, in the middle of the intersection at Broadway and Montrose, two men were sword fighting, as if in an Errol Flynn movie. While Dad gazed at them from his perch on the backstep, the pair paused for a moment to watch the engine pass, then without missing a beat, went right back to their duel. Dad mused, "Now I've seen everything." It is amusing moments such as this which help to lighten the load while working in such a demanding job.

Through any firefighter's career there are many times of heartache and grief. Every day these brave servants give their all. They deserve our appreciation and respect. Unfortunately, only one firefighter is recognized annually with either the Lambert Tree or Carter Harrison Award for heroism. They are ALL heroes. Maybe the saddest commentary on society is the fact that during my dad's entire 30-year career, only one person said thank you. He had rescued an old woman from a burning building and returned inside to fight the fire. Her son patiently waited until the blaze was out, and when Dad emerged from the structure, he ran over and said thanks for saving his mother's life. It is sad that this was the only time he ever heard thank you, after continually risking his life day after day to help others.

It is my hope that this book serves, in some small way, as a tribute to all firemen everywhere. As a society we owe them a debt of gratitude, and I will always be proud to call myself a firefighter's daughter.

EPILOGUE

In 1970, Dad was promoted to lieutenant. After 14 years at Engine 78, it was time for him to move on. I cried tears of joys at seeing him become an officer, but was saddened that he had to leave my beloved Engine 78. All of my firehouse memories were there.

For a few years, Dad "floated," serving as an officer wherever he was needed. He carried his fire coat, boots, and helmet with him in the trunk of his car to easily move from house to house. I kept a record of his travels on a list attached to my closet door. I prayed that he would end up back at Engine 78. However, he was finally assigned to Truck 21, then located at 1501 West School Street, but Dad, being an engine man through and through, was reassigned to Engine 56 at 2214 West Barry before long. He continued to serve as lieutenant at this house until his promotion to captain in 1980.

On Easter morning, he reported to Engine 4's house at 548 West Division Street, in the heart of the Cabrini Green housing project. The project is named for Mother Cabrini, the first United States citizen to be canonized a saint, in 1946, due to her work across the country in the early 1900s, organizing hospitals, orphanages, and other institutions to help those in need. Here, despite their noble fame, fires raged and tempers flared as Dad led his men in their daily battles.

In May of 1986, my Dad finally retired after 30 years of serving in this proud firefighting profession. He and my mother moved to a farm in a small town in Southern Illinois. Not knowing a soul, they bought property and built their dream house. They have since become active members of the community and enjoy a quiet rural way of life. Over the last 14 years, they have raised white-faced heifers, Corriedale sheep, Nubian goats, donkeys, 40-pound turkeys, Rock-Cornish game hens, geese, chickens, ducks, guinea hens, honey-producing bees, Springer Spaniel puppies, and assorted barn cats. In between feeding the animals and visits to town, they tend their orchard and bountiful vegetable garden. After years of living in Chicago and raising their family, this is their Shangri-La, their happily-ever-after.

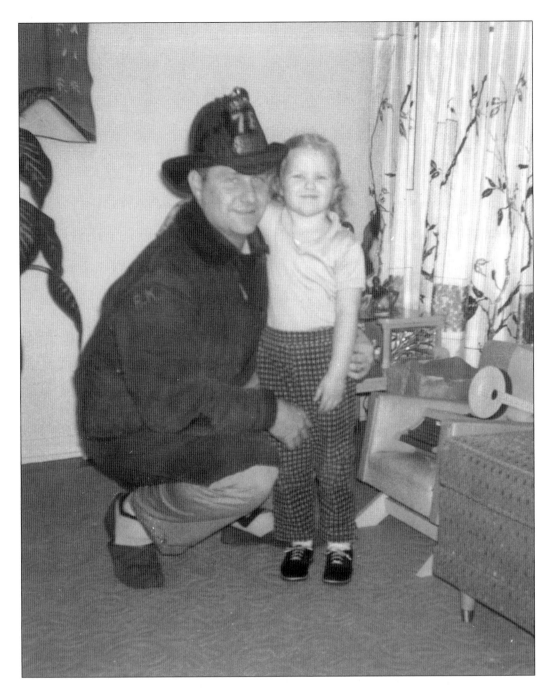

My dad is pictured here, wearing his fire gear with the proud author, in April of 1963. I was almost five years old, and Dad had already served seven years at Engine 78.

Selected Bibliography

Bales, D. "The Cause of the Great Chicago Fire." www.geocities.com/~bales1.

Beeler, Amanda. Elements Taking Toll on Totem. *Chicago Tribune.* Chicago: August 4, 1998.

Bernstein, Arnie. *Hollywood on the Lake.* Chicago: Lake Claremont Press, 1998.

Berstein, Gail. "Alta Vista Recreates Perfect London Walk." *Chicago Sun-Times.* Chicago: January 31, 1988.

Bielski, Ursula. *Chicago Haunts. Ghostly Lore of the Windy City.* Chicago: Lake Claremont Press, 1997.

Brewster, Keith. "Wrigley Snowstorm." www.galstar.com.

Burke, Tom. "Milwaukee Road Knocking at Chicago's Back Door." *The Milwaukee Railroader.* Milwaukee, WI: Milwaukee Historical Association, Third Quarter, 1995.

Callahan, Neal. "Thrill Show Draws Crowd of 80,000." *Fire Fighter.* Chicago: The Firemen's Association of Chicago, September 1958.

Chicago Bears. "Chicago Bears: The Official Site." www.chicagobears.com.

Chicago Fire Department. *Report of the Fire Commissioner of the City of Chicago.* Chicago: Chicago Fire Department, 1927.

———. *Chicago Fire Department, 1965.* Chicago: Chicago Fire Department, 1965.

———. *Chicago Fire Department Report of Progress: 1957–1967.* Chicago: Chicago Fire Department, 1967.

Chicago National League Ball Club, Inc. "Wrigley Field." www.cubs.com.

Chicago Sports Venues. "Chicago Bears." http://shrike.depaul.edu.

———. "Wrigley Field—Home of the Cubs." http://shrike.depaul.edu.

Chicago Tribune. "150 Defining Moments: Events That Shaped Chicago." http://chicago.digitalcity.com/150th/moments.

Colburn, Robert E. *Fire Protection and Suppression.* (n.l.): McGraw-Hill, Inc., 1975.

County Clerk, David D. Orr. "Cook County Vital Statistics." www.cookctyclerk.com/bform.htm.

Cowan, David and John Kuenster. *To Sleep With the Angels: The Story of a Fire.* Chicago: Ivan R. Dee, 1996.

Cutler, Irving. *Chicago: Metropolis of the Mid-Continent.* Chicago: Kendall/Hunt Publishing Co., 1982.

Dark Horse Multimedia, Inc. "The Lady in Red." www.crimelibrary.com.

Department of Planning and Development. "Chicago Landmarks." www.ci.chi.il.us/landmarks.

Drury, John. *Old Chicago Houses.* Chicago: University of Chicago Press, 1961.

Estate of Gloria Swanson, CMG Worldwide. "Gloria Swanson Biography." www.cmgww.com/stars/swanson/bio.html.

Falk, Ken, Mark Buslik, and Ken Little, ed. "History Highlights Chicago Fire Department." *Chicago Fire Department Directory "Official" Edition 1982–1983.* Chicago (n.p.) Distributed by the 5–11 Club, 1982.

Firefighting.Com and Associates, Inc. "History of the Maltese Cross." www.firefighting.com.

Hartel, William. *Once Upon a Time.* Chicago: Quality Sports Books, 1996.

Hayner, Don, and Tom McNamee. *Streetwise Chicago.* Chicago: Loyola University Press, 1988.

Hepcat Publishing. "Steve Goodman." www.hepcat.com/goodman.

Holy Trinity Lutheran Church. "Holy Trinity Lutheran Church History."
www.enteract.com/~holytic/history.htm.

Hucke, Matt. "Graveyards of Chicago." www.graveyards.com.

IAFF-Washington D.C. "International Association of Firefighters." www.iaff.org.

Idea Logical Company. "The Baseball Online Library." http://cbs.sportsline.com.

Inside Publications. "City Landmarks." www.insideonline.com/land.html.

Intellectual Reserve, Inc. "Family Search Ancestral File." www.familysearch.com.

Internet Movie Database, Ltd. "Movie Database." http://us.imdb.com.

Knowledge Adventure, Inc. "Chicago Bears: George Halas and the Monsters of the Midway."
www.letsfindout.com.

Lanctot, Barbara. *A Walk Through Graceland Cemetery.* Chicago: Chicago Architecture Foundation,
1988.

Little, Ken, and Father John McNalis. *Chicago Firehouses, 19th Century.* Chicago: 1998.

Lynch, John ed. "Thrill Show on August 3." *Fire Fighter.* Chicago: The Firemen's Association of
Chicago, June 1958.

MacIntyre, Diane. "Gloria Swanson—Filmography." www.mdle.com.

Mayer, Harold M., and Richard C. Wade. *Chicago: Growth of a Metropolis.* Chicago: University of
Chicago Press, 1969.

Mess, Dennis, James Buckley, and Ted Schnepf. "Evanston via Chicago, Milwaukee, and St. Paul." *The
Milwaukee Railroader.* Milwaukee, WI: Milwaukee Historical Association, June 1984.

Metromix. "Billy Goat Tavern." http://metromix.com.

Munsey and Suppes. "Ballparks." www.ballparks.com.

Music Box Theatre. "Music Box Theatre." www.musicboxtheatre.com/musicboxhistory.html.

NFL ProWeb. "NFL History." www.nf.proweb.com/NFLHistory.

O'Brien, Ellen, and Lyle Benedict, Municipal Reference Library. "CPL Deaths,
Disturbances, Disasters, and Disorders in Chicago." http://cpl.lib.edu/oo4chicago/chidisaster.html.

Oliver. "Gloria Swanson." http://home.hiwaay.net/~oliver/gschildhood.htm.

Pro Football Hall of Fame. "Chicago Bears." www.profootballhof.com/histories/bears.html.

Puls, Mark. "Wrigley, Fenway are Baseball's Last Classic Cathedrals." *The Detroit News.* Detroit:
September 27, 1999.

Royko, Mike. *One More Time: The Best of Mike Royko.* Chicago: University of Chicago Press, 1999.

Ryan, Nancy. "Back to Site of Lakeview Landmark Flight in '96." *Chicago Tribune.* Chicago: March 19,
1998.

Salvation Army. "The Salvation Army." www.salvationarmy.org and www.salarmychicago.org.

Schulze, Franz, and Kevin Harrington. *Chicago's Famous Buildings.* Chicago: University of Chicago
Press, 1993.

Sinkevitch, Alice, ed. *A/A Guide to Chicago.* New York: Harcourt Brace and Company, 1993.

SMG. "Soldier Field—History." www.soldierfield.net/history.html.

Swanson, Gloria. *Swanson on Swanson.* New York: Random House, 1980.

Taylor, Troy. "The Biograph Theater." www.prairieghosts.com.

Tipton, Jim. "Find-A-Grave." www.findagrave.com.

Toland, John. *The Dillinger Days.* New York: Avon Books, 1969.

Veeck, Bill, with Ed Linn. *Veeck: As in Wreck: The Autobiography of Bill Veeck.* New York: Putnam,
1962. Veterans of Foreign Wars of United States. "Origins of Veterans Day."
www.vfw.com/amesm/origins.shtml.

Waveland Restoration Group. "Jacob A. Wolford Memorial Tower." Chicago: (n.d.)